IMAGES
of America

GALLOWAY
TOWNSHIP

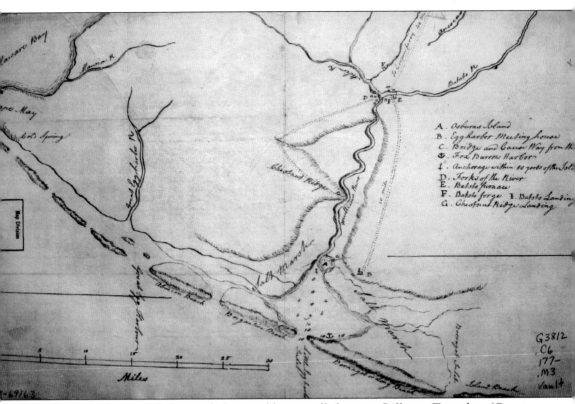

A . Osborns Island
B . Egg Harbor Meeting House
C . Bridge and Cause Way from th
✠ . Fox Burrow Harbor
✦ . Anchorage within 50 yards of the Isl.
D . Forks of the River
E . Batsto furnace
F . Batsto forge ⚓ . Batsto Landing
G . Chestnut Ridge Landing

This is the first recorded map of what would eventually become Galloway Township. (Courtesy of the Galloway Township Historical Society.)

ON THE COVER: This image in Clarks Landing offers a peek into the lives of the Weber family and friends in the early 1900s. The name Clarks Landing most likely derived from Capt. James Clarke, who often sailed the Mullica River prior to his ship, *Royal Charles*, sinking on its way to New York in 1690. (Courtesy of the Galloway Township Historical Society.)

IMAGES
of America

GALLOWAY
TOWNSHIP

Joseph Federico and Matthew McHenry
Introduction by Robert Lee Reid

ARCADIA
PUBLISHING

Published by Arcadia Publishing
Charleston, South Carolina

Printed in the United States of America

Library of Congress Control Number: 2010932748

For all general information, please contact Arcadia Publishing:
Telephone 843-853-2070
Fax 843-853-0044
E-mail sales@arcadiapublishing.com
For customer service and orders:
Toll-Free 1-888-313-2665

Visit us on the Internet at www.arcadiapublishing.com

*The authors would like to dedicate this book to the people
of Galloway Township: past, present, and future.*

CONTENTS

ACKNOWLEDGMENTS

This book has been a three-year labor of love, and the authors would like to take this time to thank some very special people who helped, encouraged, and provided for to make this a reality.

First and foremost, we would like to thank the Walsh family of Galloway Township. It was the curiosity of their historic home that led to this project literally landing in our laps. Thank you for generously providing us with meals and a place to stay during our countless trips up and down the parkway and, of course, for the use of your scanner.

There were also several families and businesses that helped us along the way. They welcomed us into Galloway's history with open arms and open photo albums, sharing with us personal histories and fascinating stories. Thank you to Ed and Wendie Fitzgerald, Susan Humphrey, our friends at the Renault Winery, our friends at the Absecon Lighthouse, Joyce Kintzel, Cynthia Lamb, Richard LaLena, Ernest F. Kidd, our friends at the Galloway and Mays Landing locations of the Atlantic County Library, Judith Courter, our friends at the Noyes Museum of Art, our friends at the Atlantic County Heritage Center of New Jersey, Jim and Anna Higbee, the Grunow family, the Ingersoll family, Mark Maxwell, Don Kelly, Mainland Baptist Church, Emmaus United Methodist Church, the Hammell family, and our friends at Kennedy's Bar.

Also, the authors would like to give a very special thank you to Robert Reid, Ken Sooy Sr., and the Galloway Township Historical Society. Without their insight, resources, connections, and continuing help, this project would never have left the ground.

A special thanks to the authors' respective families for the support and encouragement to pursue what at first seemed a pipe dream and then eventually became a reality.

Lastly we would like to thank Erin M. Rocha, our editor, who was never further than a phone call or mouse click away from day one. Thank you, Erin, for giving us the opportunity to pay homage to an interesting township that has been such an important part of both our lives.

INTRODUCTION

The following pictorial collection of people, places, and progress in "Old Galloway" is not intended to give a complete history of Galloway Township. The following is offered only by way of introduction as a brief jaunt through Galloway history.

The history of the Galloway area dates back over 8,000 years, with the first settlement of the Lenni Lenape people. Before European settlers arrived, the local inhabitants lived off the natural resources of the wildlife of the woodlands, streams, rivers, bays, and ocean. They cultivated corn and tomatoes—foods unheard of in Europe. With the coming of the Europeans, the Lenni Lenape culture was doomed.

Galloway was explored in the 16th century by Dutch, French, Swedish, Finnish, and Portuguese sea captains. The first survey was made by Henry Hudson in 1609. Cornelius Jacobsun Mey sailed into Little Egg Harbor in 1614 and later charted the coastline.

In 1664, Charles II of England granted his brother James, Duke of York, the land between the Hudson and Delaware Rivers. James presented the land to two of his favorites—Lord John Berkeley and Sir George Carteret. He named the new land Nova Caesarea. Today the boundaries of Nova Caesarea (New Jersey) are exactly as set about in the original Duke of York's deed.

Galloway has an interesting historic past dating back before 1716, when Kings Highway was constructed along an Indian trail now known as Old New York Road. Before 1774, the place now called Galloway was numerous small villages and hamlets in Gloucester County, inland of Absecum Beach in the province of West New Jersey. On April 4, 1774, King George III granted a royal patent for the creation of the Township of Galloway. It was formed in Gloucester County from Egg Harbor Township and was much larger than it is today. Galloway Township once included Absecon, Brigantine, part of Atlantic City, Port Republic, Mullica, Hammonton, Egg Harbor City, and a portion of Burlington County.

The State of New Jersey Public Record Office in 1929 stated that it could not tell positively for whom the Township of Galloway was named but suspected it was named after Joseph Galloway. Joseph Galloway was a successful lawyer and leading political figure in Pennsylvania for a generation before the American Revolution. He was ideological and a strict constitutionalist. For many years, Galloway was Benjamin Franklin's chief ally. Both labored mightily for a generation to reconcile the colonies with the mother country. They grew farther and farther apart as Franklin was pushed by events into a more radical stance. Since Franklin worked mostly in London, Galloway's forum was in America, principally the Pennsylvania Assembly, where he was Speaker of the House for a decade, and ultimately the Continental Congress. In 1774, Galloway's Plan of Union lost in the Congress by only one vote—a loss that changed the course of history, since Galloway tried to avoid revolution by anticipating the British commonwealth system. In 1775, when the assembly ignored Galloway's recommendation that it abandon its defiance of Britain, Galloway quit the assembly and the congress. He remained steadfast in his belief that "the most proper Plan for cementing the two countries together" would have been constitutional, granting

"America the same rights and privileges as are enjoyed by the subjects in Britain." As a result of Galloway remaining loyal to Britain, he lost position and all his land holdings in America and returned to Britain penniless.

Prior to the American Revolution, many seamen engaged in smuggling or illegal entry into port to avoid payment of duty. They justified this practice by claiming that the British Maritime Commission discriminated against them and that duties were imposed without their consent. Many smugglers operating on the Mullica River became privateers.

Several naval threats by the British at the village of Chestnut Neck caused Fort Fox Burrows to be built in June 1777. Chestnut Neck along the Mullica River was a thriving port carrying on a brisk trade during the Revolutionary War; its boats going into Great Bay would seize British supply vessels and send the captured supplies to the American army. In September 1778, a British force of nine ships and 400 men was dispatched to destroy the nest of privateers in Chestnut Neck. Count Pulaski and his Continental troops were sent by General Washington to protect the port. They did not arrive in time. On October 6, 1778, the British captured the Fort Fox Burrows, destroyed all of the vessels in the harbor and pillaged and burned the town. On October 14, the British and the Continental forces clashed at Osborn's Island on the Mullica. The Continentals were outnumbered and butchered. The Battle of Chestnut Neck, apart from the massacre at Osborn's Island, was actually not a great victory for the British. The privateers, or "rebel pirates" as the British called them, continued to harass British shipping until the end of the war.

Looking back, most of Galloway roads in the early part of last century were not paved. The planned unit developments did not exist. A majority of growth was clustered in small villages and hamlets such as Smithville, Leeds Point, Oceanville, Higbeeville, Cologne, Pomona, Absecon, Germania, Port Republic, Chestnut Neck, and many others. About 1821, the road to Camden's ferries on the Delaware River was built through Galloway, starting in the village of Absecon. This highway is now known as Church Street and New Jersey Avenue in Absecon and White Horse Pike in Galloway.

In 1854, with the effort of Dr. Jonathan Pitney, a railroad was constructed from Camden to the village of Absecon through Galloway. With the coming of the rails and the growth of Atlantic City, Galloway was increasing in population. Galloway's development is closely tied to Atlantic City. Dr. Jonathan Pitney, of the village of Absecon in Galloway Township in the 19th century, had an idea for a health resort on Absecon Island. His vision became Atlantic City.

Absecon Creek and the Mullica River were the major transportation routes. Wharves lined the creek and river; boats both large and small were constructed along the banks. Shipbuilding began at the mouths of rivers and bays and was concentrated on the broad, large waterways with deep channels and unobstructed access to open water. This was the era of the wooden ship. Early shipbuilding was crude planking sawn by hand, then shaped and fitted with broadax and plane. The work was slow and arduous. American ships were noted for their cost; they were inexpensive to build. New Jersey's shore communities had all the prerequisites for successful shipbuilding: coastal commerce was close at hand; varied forestlands provided good timber; a ready supply of skilled labor was available; and local furnaces forged nails, fittings, and implements. Whaleboats were being built by the early 18th century. Then fishing boats were produced. South Jersey shipyards were plentiful and busy. A good portion of Atlantic County residents depended upon shipbuilding for their livelihood. By the first half of the 19th century, there were shipyards in Absecon and Port Republic in Galloway. Absecon Creek was a major center with its small stream and deep channel. Between 1858 and 1879, over 23 vessels were built at Absecon Creek and registered at Great Egg Harbor.

In 1854, German immigrants from Philadelphia traveling through Galloway to Atlantic City via the new railroad marveled at the vast open space in the area. They later invested in the western part of Galloway, where they created the Gloucester Town and Farm Association Farm and Villas development plan. This encompassed a large portion of western Galloway, which was divided up into large farm lots and small town lots that became Egg Harbor City.

During the Civil War, Galloway residents volunteered to serve in the Union army. The only

evidence found in Galloway records regarding the Civil War is for 1866. An estimated 52 Galloway residents served. Pitman Adams of Unionville (Port Republic) lost an arm at Cold Harbor, Virginia, and died at home of typhoid fever. David Hewtit was wounded and taken prisoner at Chancellorsville and later died. J. Morris Cavalier and Mark Johnson were killed at Far Oaks, and Samuel Cavalier served with distinction and returned home a lieutenant.

In terms of transportation at the time, things were much different than today. In earlier years, Moss Mill Road and the road to Cooper's Ferry were the main stagecoach routes through the township to Samuel Cooper's ferry in Camden.

In the 1920s, the now less expensive automobile was making a major impact on the region's transportation system. People were using their cars and frequenting the train less and less. With the freedom the individual automobile gave, travelers were no longer willing to wait for the train. A person could just hop in a car and head to the shore whenever he or she felt like it. By 1932, Galloway had an extremely successful resort nearby called Atlantic City. As a result, there was a need for a state highway to go through the area to provide another automobile route to the beach town. Thus, U.S. Route 30 was constructed through quiet Galloway. Now that Galloway had a state highway running through it, more commercial growth was spurred. Tourist camps with cabins and restaurants began popping up along the roadway. Around the time when Route 30 was constructed, the Great Depression hit the nation, subsequently slowing down development.

Following World War II into the 1950s and 1960s, there was a period of great expansion for the entire country, including Galloway. With many people now owning a car, new hotels and motels sprang up throughout the area. With the advent of cheap airfares and air conditioning, the region's decline slowly began. It was in full swing by the early 1970s. Talk began at this time of legalized gaming to bring prosperity back. The first casino opened in 1978, which started the area's economic rebirth. With this came population, jobs, and congestion from the early 1980s to the present day.

Whether you are an old-timer or newcomer, a resident or summer visitor, a history buff or just enjoy photographs, you will enjoy reading the captions and thumbing through the pages of this book.

—Robert Lee Reid

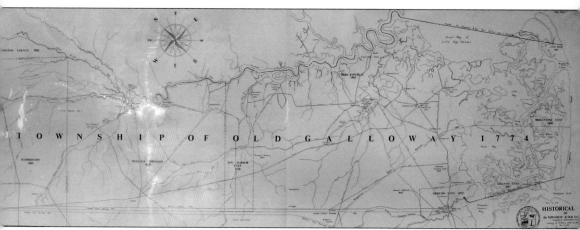

This is a map of Olde Galloway. (Courtesy of the Galloway Township Historical Society.)

One

FAMILIES

When someone thinks of Galloway Township, the first things that come to mind are some of the well-known family names—Leeds, Higbee, Conover, Bowen, Smith, and Noyes, to name a few. It is no surprise that Higbeetown, Conovertown (formerly Conoverville), and Leeds Point are some of the subdivisions in the area. Since Galloway once encompassed land from the parkway to the tip of Atlantic City, it makes sense that the people of Galloway are as diverse as its geography.

Over time, sections of the original township, now known as Olde Galloway, have become other towns completely. Despite these changes, many people who no longer live in the literal limits of the township still insist they live in Galloway. That speaks to the wonderful feeling one gets in Galloway. Most of the roads in the township are named after some of the founding families. Ethel and Fred Noyes were so prolific in both the development of Historic Smithville and their artistic endeavors that they have an entire art museum named after them. Despite these easily recognizable names, the area of Galloway Township is chock full of local and personal history; every family name has a story to tell, something to share with everyone. The people range from German and Russian immigrants grabbing hold of their America dreams to established families with roots going back to the 1800s.

When one thinks back on the area's rich history, the land's original inhabitants, the Lenni Lenape must be remembered. In several points around the township, there is evidence of burial mounds, and an entire canoe was uncovered not far from Leeds Point. Also attesting to the Native Americans in the area of what is now Galloway are piles of clamshells, arrowheads, and small stone tools.

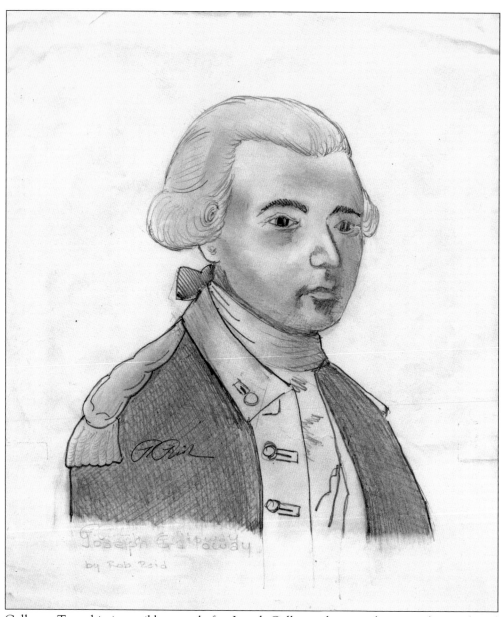

Galloway Township is possibly named after Joseph Galloway; he was a lawyer and top political figure in the state of Pennsylvania for a generation before the American Revolution. Galloway served General Howe as a compiler of intelligence reports and as a recruiter of Loyalist troops. It is also said that Galloway may have been named after Mull of Galloway in Scotland. (Courtesy of the Galloway Township Historical Society.)

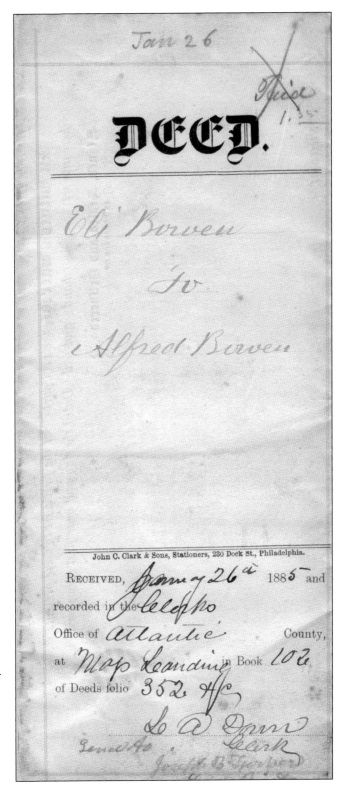

This deed, dating back to 1885, shows the formal transfer of land between Eli and Alfred Bowen. The language was so different in the 19th century; words and phrases used include "witnesseth" and "of our Lord." (Courtesy of Jim and Barbara Ingersoll.)

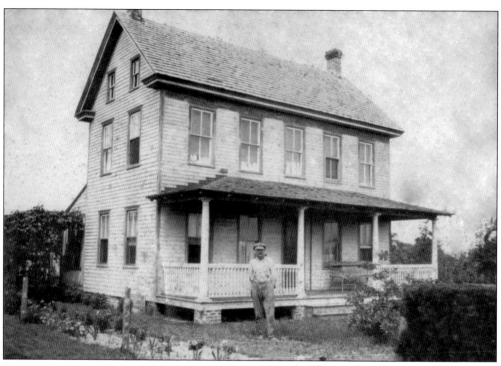

This is what the original Bowen family house looked like. The home stands on what used to be called Cow Lane; today it is called Smith-Bowen Road. (Courtesy of Jim and Barbara Ingersoll.)

Atlantic Real Estate and Investment Company

POST OFFICE BUILDING, MAY'S LANDING, N.J.

SEARCH No. 4210

Against premises situated in the Village of Leeds Point, Galloway Twp. in the County of Atlantic and State of New Jersey.

Description— Beg. at a cedar tree standing on the N. side of Smith's lane said tree being corner to Edward Heintzer (formerly William L. Risley) and runs thence
(1) N. 77 deg. W. 14 chs. and 20 links to a stake corner to William Dutch's land (formerly D. Bowens); thence
(2) N. 13 deg. E. 9 chs. and 25 links to a stake corner to D. Bowen's heir; thence
(3) S. 82 deg. E. 3 chs. and 40 links to Thomas Gibersons; thence
(4) along said Gibersons line S. 3 deg. W. 3 chs. and 75 links to a stake corner to Gibersons; thence
(5) along said Gibersons line S. 80 deg. E. 10 chs. and 40 links to centre of Smith's lane; thence
(6) along said lane S. 15 deg. W. 6 chs. and 64 links; thence
(7) N. 77 deg. W. 10 links to the place of beg.
Containing 9.25 acres, more or less.

#1. Deed.

Eli Bowen,) Dated Dec. 13, 1881
Marital condition not stated) Ack'd. Dec. 13, 1881
 to) Rec. Jan. 26, 1885
Alfred Bowen son of said) Book 102 page 352
Eli Bowen) Cons. $100.

doth grant, bargain, sell.............unto the said party of the second part, his heirs and assigns, all the following described tract of land situate in the Township of Galloway............ bounded and described as follows:-
Description:-
 On the E. by the land of Jonas Smith, on the S. by land of William L. Risley, deceased, on the W. and N. by lands of the heirs of Josiah Bowen and others and is the property that said Eli Bowen now lives on and is the property that Thomas Bowen deceased left by will to said Eli Bowen in reference to said will of Thomas Bowen will be more fully explained &c.

#2. Recognizance.

Bowen, A. E., defendant.
Date of Acknowledgment, Oct. 12, 1914.
Date of Filing, Oct. 13, 1914
Date for Appearance, Oct. 13, 1914
Amount $200.
Other Surety, James Smith.

Book 3 page 39.

This image shows an original piece of an Atlantic Real Estate and Investment Company property deed owned by the Bowen family. (Courtesy of Jim and Barbara Ingersoll.)

This is the residence of Christopher Gaupp Jr. Today the Gaupp family has a street named after them in Galloway. (Courtesy of the Egg Harbor City Historical Society.)

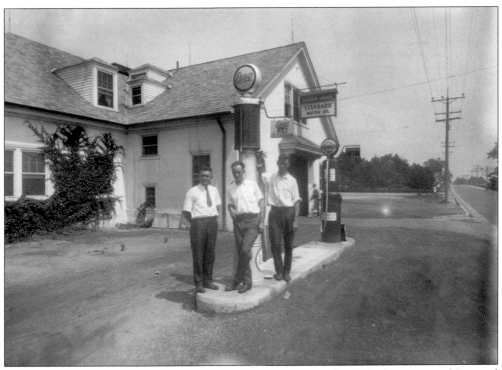

This photograph was taken in Absecon, New Jersey, in July 1928. (Courtesy of Jim and Anna Higbee.)

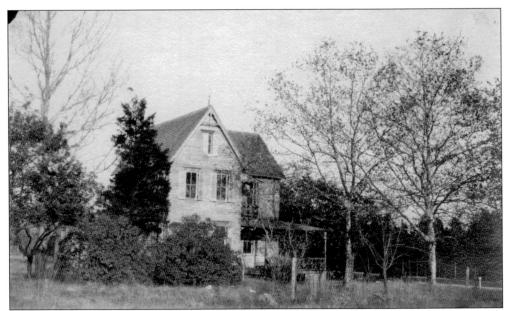

Above is the old McDevitt residence on November 10, 1923. (Courtesy of Jim and Anna Higbee.)

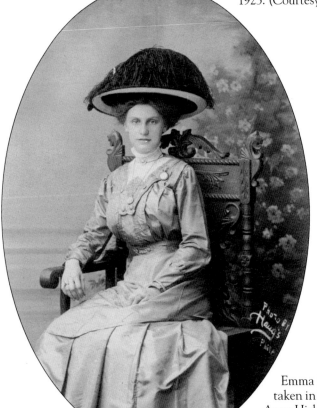

Emma Seidel sits to have her photograph taken in July 1910. According to her relative Anna Higbee, "she was a very 'straight' woman," meaning she was very proper. (Courtesy of Jim and Anna Higbee.)

This photograph was taken at Lily Lake Park on September 25, 1923. (Courtesy of Jim and Anna Higbee.)

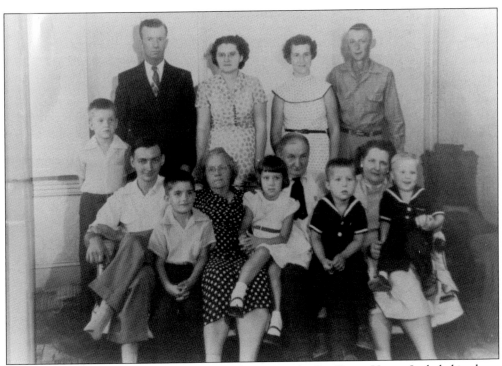

This is a Higbee family portrait taken in Leeds Point at the Big Green House. Included in the c. 1955 photograph are, from left to right, (first row) Jim Higbee, Ronald Morsord, Bessie Higbee, Linda Higbee, Fred Higbee, Johnny Higbee, Margarite Higbee, and Bobby Higbee; (second row) Jimmy Morford, Ralph Morford, Sarah Morford, Evelyn Morford, and Edward Higbee. (Courtesy of Jim and Anna Higbee.)

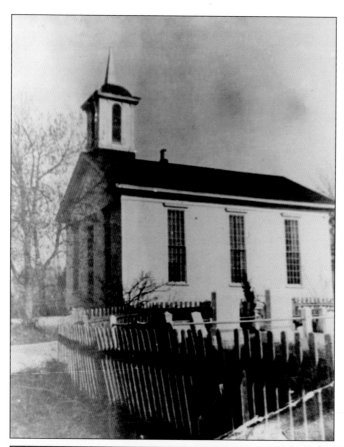

This is the Emmaus United Methodist Church, located on East Moss Mill Road. It was built around 1790. Many prominent founding families of the area have been buried in this cemetery. (Courtesy of the Galloway Township Historical Society.)

Below is a modern photograph of the historic church. Not much has changed over the centuries, and many people still worship here to this day. (Courtesy of Ken Sooy Sr.)

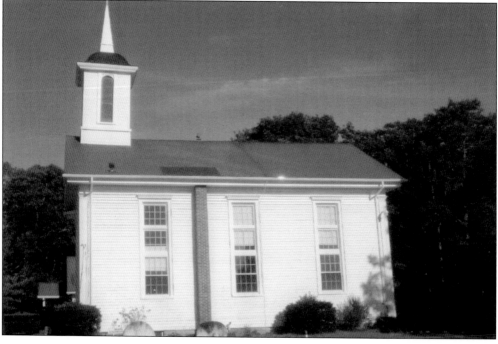

Here artist James D. Barnett Jr. depicts an early version of the Emmaus Church along with a visiting circuit rider. (Courtesy of the Emmaus United Methodist Church.)

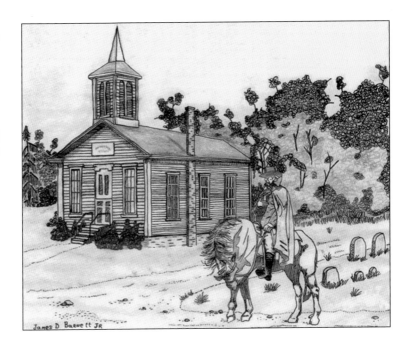

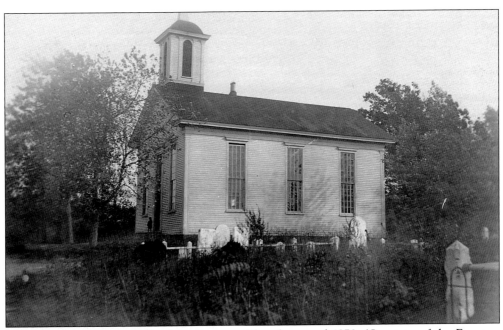

This is another photograph of the Emmaus Church around 1870. (Courtesy of the Emmaus United Methodist Church.)

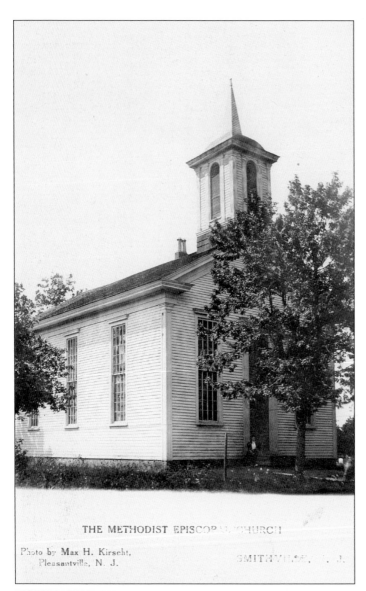

THE METHODIST EPISCOPAL CHURCH

Photo by Max H. Kirscht,
Pleasantville, N. J. SMITHVILLE, N. J.

This photograph of the Emmaus Church was taken around 1909. (Courtesy of the Emmaus United Methodist Church.)

This is the first Mainland Baptist Church congregation in 1954. (Courtesy of the Mainland Baptist Church.)

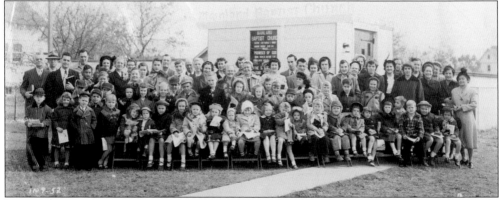

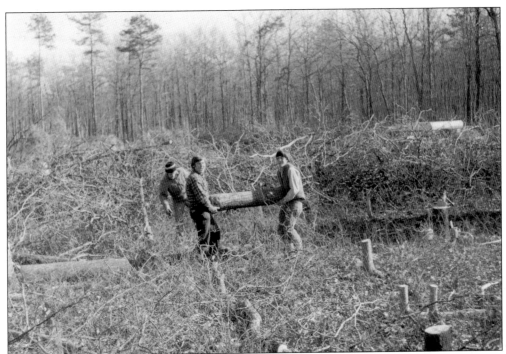

Here trees are being cleared in the area that would be the future home of Mainland Baptist Church, located on Pitney Road. (Courtesy of the Mainland Baptist Church.)

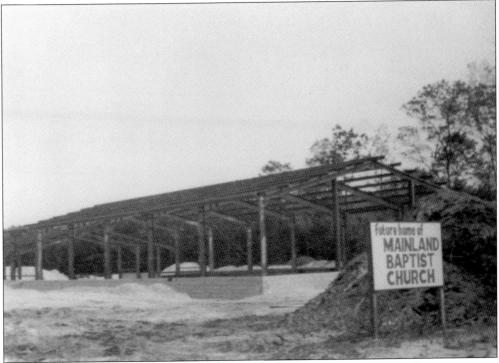

This is the foundation and steel girders of the Mainland Baptist Church while under construction. (Courtesy of the Mainland Baptist Church.)

MAINLAND BAPTIST CHURCH
Absecon, New Jersey
1947-1997

50th Anniversary Celebration

Saturday, August 2, 1997

Dean F. Bult, Sr., Pastor

Dean F. Bult, Jr., Assistant Pastor

Howard M. Bird Jr., Visitation Pastor

Schedule Of Events

12:00 p.m. . . . Chicken Bar-b-que On The Grounds

1:30 p.m. Remembering Our Church History
 With Folks Who Were Part Of It

2:30 p.m. Music Celebration
 Liberty Summer Singers
 Liberty University, Lynchburg, VA

4:00 p.m. 50th Anniversary Cake Cutting

On behalf of the staff and congregation of Mainland
Baptist Church we would like to thank you for being
a part of our 50th Anniversary celebration. As we
reach this milestone we would also like to give
thanks to the Lord for how he has richly blessed
our church.

For future posterity we would like for each family
to list their names, ages & addresses in our guest
book located in the foyer.

Mainland Baptist Church celebrated its 50th anniversary in Galloway in 1997. (Courtesy of the Mainland Baptist Church.)

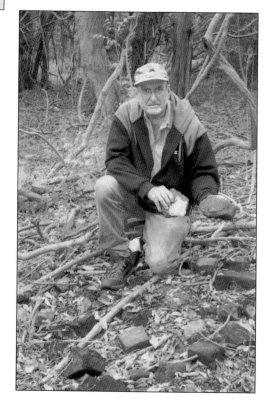

This is a modern photograph of Ken Sooy Sr. He is a prominent member of the community and serves on the Galloway Historical Society committee. (Courtesy of Ken Sooy Sr.)

This is a tintype taken of Mary Louisa Channell Leeds and Abraham Lincoln Leeds about 1884, the year they were married. (Courtesy of Joyce Kintzel.)

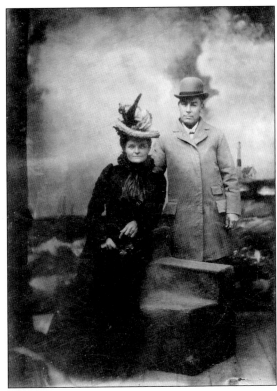

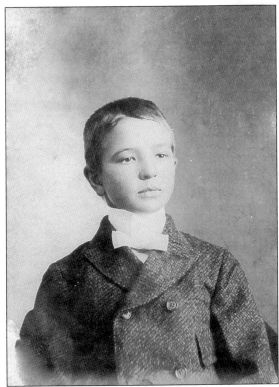

This photograph of Charles Stewart Leeds, son of the above Leedses, was taken sometime after his birth in Galloway in 1885 but before he left at age 13 to work on a farm in Hunterdon, New Jersey. (Courtesy of Joyce Kintzel.)

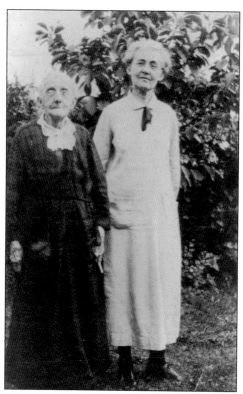

This photograph shows Sarah Newton (right) and her mother, Laura or Josephine Adams, in the early 1900s. (Courtesy of Cynthia Lamb.)

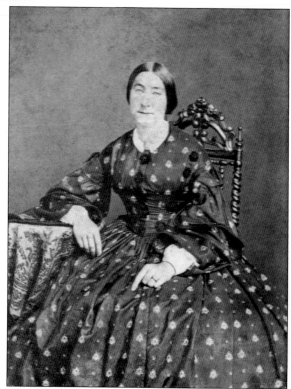

This is an earlier photograph of Sarah Newton in the mid-1800s. (Courtesy of Cynthia Lamb.)

Seen in this early-1800s photograph, Aunt Mattie Maxwell was the sister of Dr. Stacy Kirkbride. (Courtesy of Cynthia Lamb.)

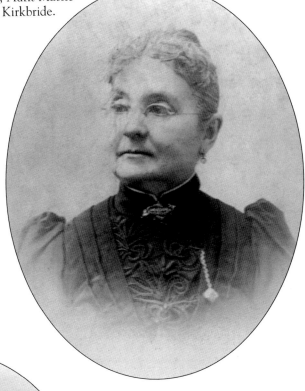

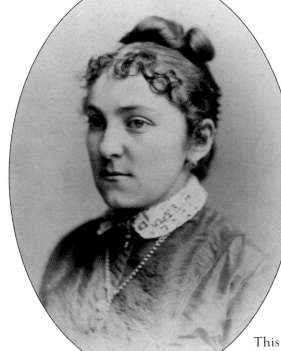

This is another photograph of Aunt Mattie Maxwell in the mid- to late 1800s. (Courtesy of Cynthia Lamb.)

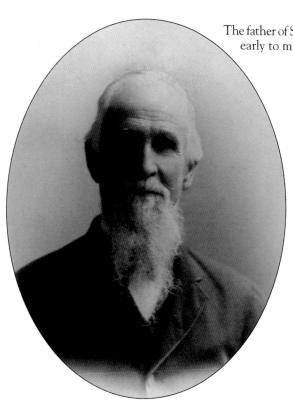

The father of Stacy Kirkbride is photographed here in the early to mid-1800s. (Courtesy of Cynthia Lamb.)

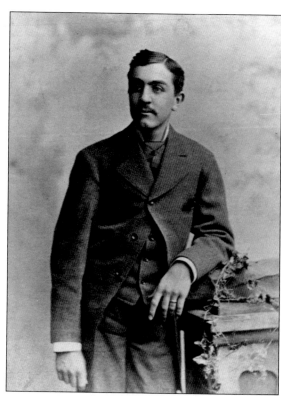

Here is a *c.* 1856 photograph of Dr. Stacy B. Kirkbride. (Courtesy of Cynthia Lamb.)

This c. 1900 photograph is of the mother of Dr. Stacy Kirkbride. She was a well-respected woman and prominent member of her community. (Courtesy of Cynthia Lamb.)

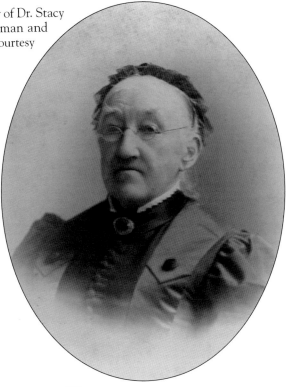

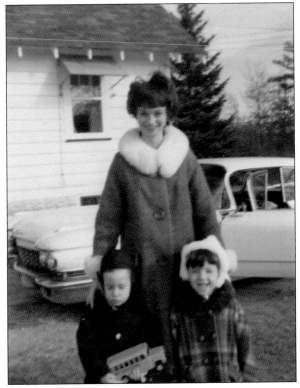

Pictured here around 1965 are mother Diane Duran (center) and her children Michael Lamb (left), and Cynthia Lamb in front of their grandmother's house. They lived with June Leeds Toler and Joseph Toler while their father, Mike Lamb, was stationed in Vietnam. (Courtesy of Cynthia Lamb.)

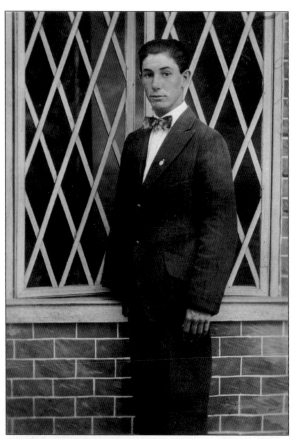

This unidentified young man from around the early 1950s is headed to his first day of school. (Courtesy of the Galloway Township Historical Society.)

In the early 1950s, a group of friends prepares to spend a day out at sea sportfishing. (Courtesy of the Galloway Township Historical Society.)

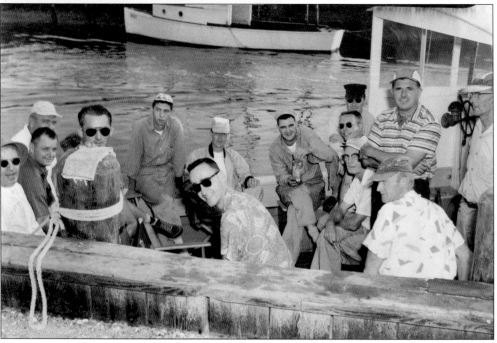

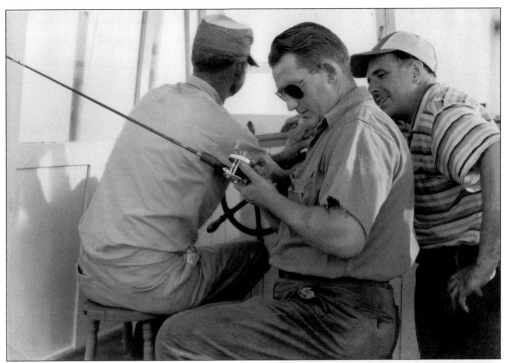

Above is the same group of men shown caught up in the fishing action. (Courtesy of the Galloway Township Historical Society.)

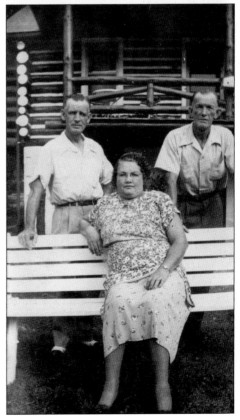

Posing here is a lovely typical family from the 1950s. (Courtesy of the Galloway Township Historical Society.)

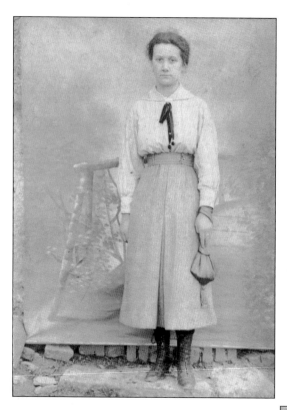

This young unidentified woman from the early 1900s is posing in front of a predesigned set that features a decorative bridge. (Courtesy of the Galloway Township Historical Society.)

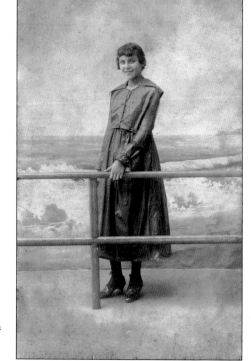

Similarly, this young woman, who looks like she is ready for a day in the sun, is also posing in front of a predesigned set that consists of a beach theme and faux boardwalk railing. (Courtesy of the Galloway Township Historical Society.)

Evidently, such photographic portraits were quite popular. This woman seems to be dressed up for an important occasion around 1915. (Courtesy of the Galloway Township Historical Society.)

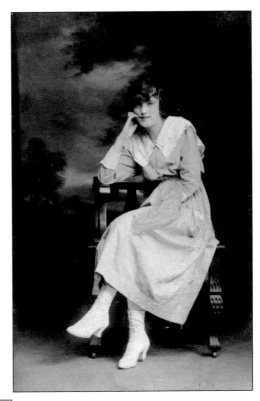

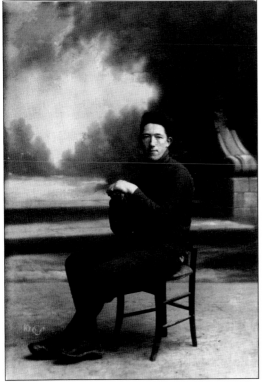

This solemn-looking young man is posing in front of a backdrop of a building facade. (Courtesy of the Galloway Township Historical Society.)

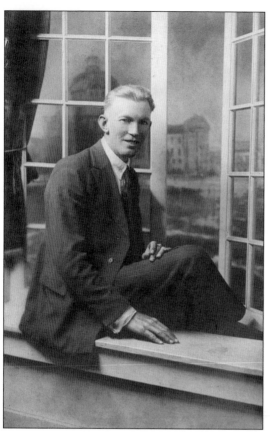

This photographic set is a little more sophisticated and leaves a little less for one to imagine. The man posing at left looks right at home. (Courtesy of the Galloway Township Historical Society.)

This friendly looking group of men poses at a function, possibly at Clarks Landing, where many important family occasions took place. (Courtesy of the Galloway Township Historical Society.)

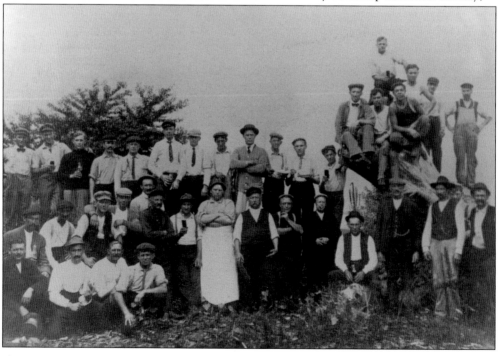

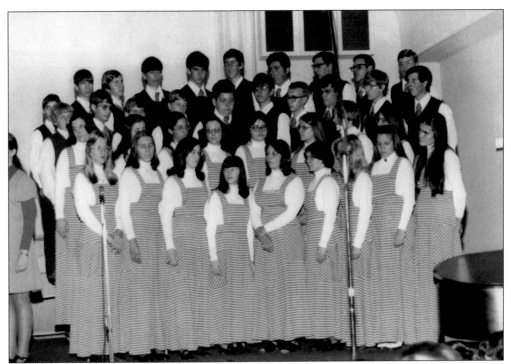

Here a group of teenagers prepares to sing at a school event in the early 1960s. (Courtesy of the Galloway Township Historical Society.)

This is a sketch of the house belonging to Louis Dammann. The pencil drawing shows the residence, located near the cigar factory, as it looked in the beginning. (Courtesy of the Galloway Township Historical Society.)

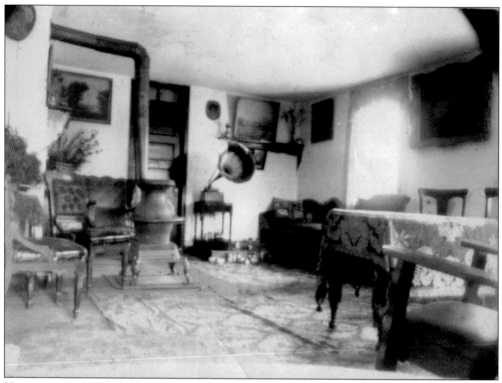

Here is a c. 1920 pinhole photograph of the Dammann family's parlor. (Courtesy of the Galloway Township Historical Society.)

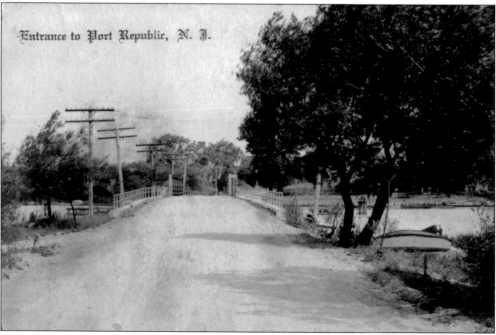

This is the entrance to Port Republic many years before pavement was put down to satisfy modern conveniences such as the automobile. (Courtesy of the Galloway Township Historical Society.)

An unidentified traveler solemnly sits while having his portrait taken in a studio. (Courtesy of the Galloway Township Historical Society.)

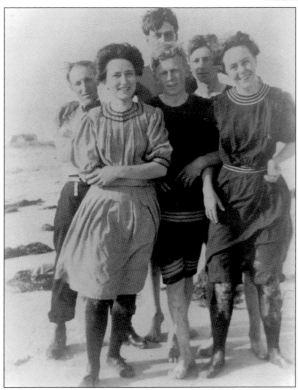

Beach babes pose in the midst of enjoying a day at the shore. This is a c. 1920 church picnic attended by Oceanville and Smithville lovelies. (Courtesy of the Galloway Township Historical Society.)

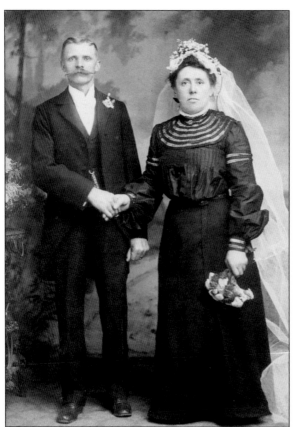

This is Mr. and Mrs. Brockmann, parents of Dorothy Hammell. They immigrated to and settled in Galloway Township. (Courtesy of Stanley and Dorothy Hammell.)

William Alfred Hammell, son of Charlie and Elizabeth Hammell, is pictured with duck decoys and a sneakbox, possibly in the Great Egg Harbor Bay. A sneakbox is a miniature boat that can be sailed, rowed, and even sculled. (Courtesy of Stanley and Dorothy Hammell.)

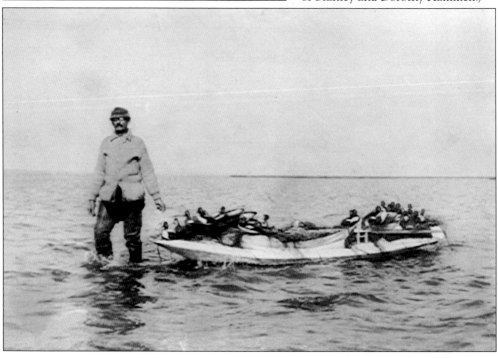

William Alfred Hammell is seen here in action, patiently waiting in his hunting gear with a cocked gun. (Courtesy of Stanley and Dorothy Hammell.)

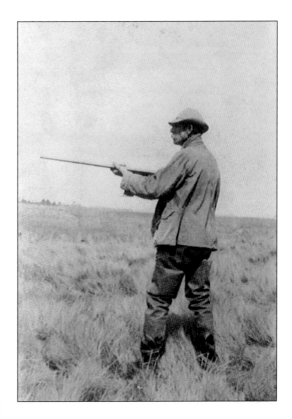

This is possibly a photograph of Ernst Grunow taking a break from hunting festivities. (Courtesy of Stanley and Dorothy Hammell.)

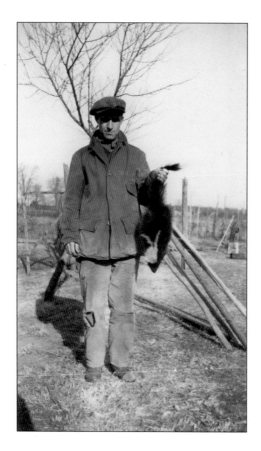

Stanley Hammell's father proudly showcases his catch of the day. (Courtesy of Stanley and Dorothy Hammell.)

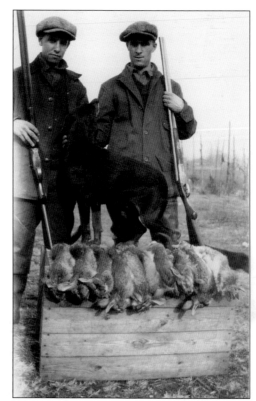

Stanely Hammell's father and best friend pose with rabbits after a hard day of hunting. (Courtesy of Stanley and Dorothy Hammell.)

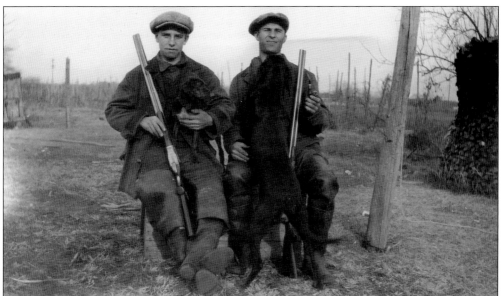

Hammell and his best friend pose in a field with their other best friends, their dogs. (Courtesy of Stanley and Dorothy Hammell.)

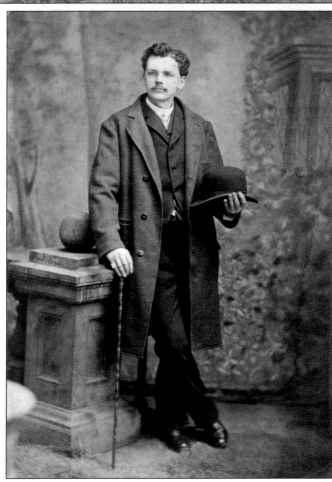

Ernest Grunow, Albert Grunow's brother and Willard Grunow's great-uncle, stands while his picture is taken. Ernest Grunow lived from 1858 to 1886. (Courtesy of Willard and Loris Grunow.)

Here is an image of Albert Grunow, brother of Ernest Grunow. (Courtesy of Willard and Loris Grunow.)

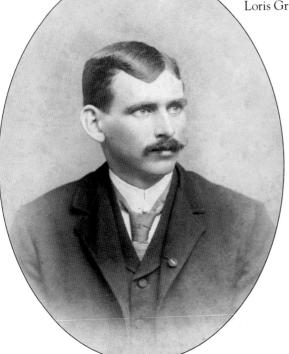

Here is an image of Bertha Liepe Grunow, wife of Albert Grunow and grandmother of Willard Grunow. This photograph and the one above are possibly examples of wedding photography. (Courtesy of Willard and Loris Grunow.)

Ernst Grunow, pictured here, was the father of Willard Grunow. Ernst died in 1931 when Willard was only 5 years old. (Courtesy of Willard and Loris Grunow.)

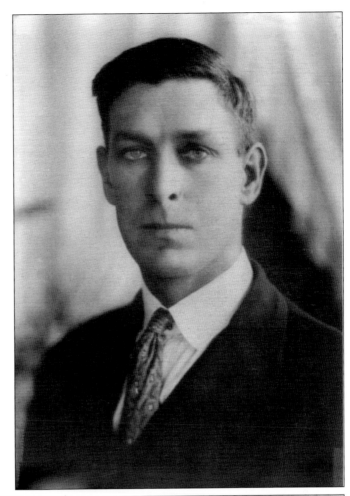

Ernst Grunow (below, left) and his friend Harry Parker take the car out for a mid-afternoon drive around 1920. (Courtesy of Willard and Loris Grunow.)

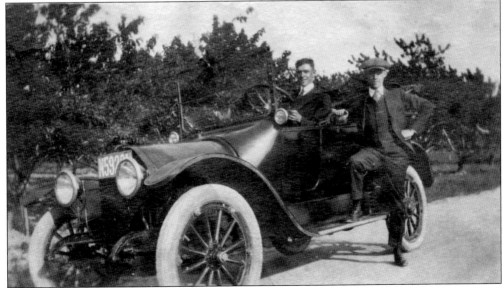

Martha Sahl (left), Joseph Sahl Sr. (center), and Joseph Sahl Jr. pose in front of their farmhouse around 1903. Anna Higbee is a half cousin to the Grunow family through marriage. Willard Grunow's mother and Anna Higbees's mother were both members of the Sahl family. (Courtesy of Willard and Loris Grunow.)

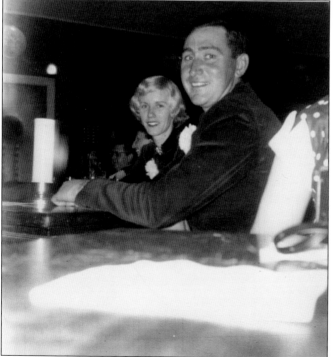

Willard and Loris Grunow pose happily at a family function about 1950. (Courtesy of Willard and Loris Grunow.)

Two

AGRICULTURE

One of the things that people notice about Galloway is that when they drive out of the areas that have been developed, they find acres upon acres of farmland. Much of this land was once covered with forests, but as early settlers and developers cut down timber, it was never replaced. Cedars were felled to make boards and planks, and yellow pine was harvested to make charcoal and firewood. This ever-changing backdrop played host to some of the most important parts of Galloway's history and development.

Agriculture has been one of the defining factors in what makes Galloway the township that it is today. At first, farming and exporting wheat was a major facet of Galloway's economy, most notably in the Pomona area. When more profitable wheat farms began operating farther west, the acreage in Galloway gave way to fruit and vegetable cultivation. This continues to be an important part of Galloway's agriculture—notably potatoes and sweet potatoes.

One of the trademarks of Galloway is a seemingly perpetual change to the landscape. Despite the fact that some, if not most, of the family-owned farms have been sold to larger companies, some families still produce seasonal items like pumpkins and Christmas trees each year.

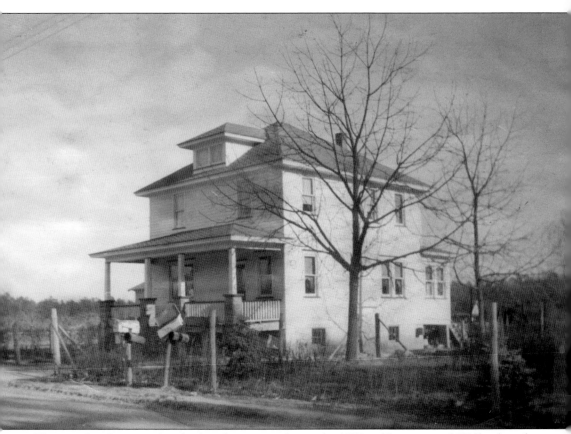

This is the Grunow family farmhouse in the early 1950s. (Courtesy of Willard and Loris Grunow.)

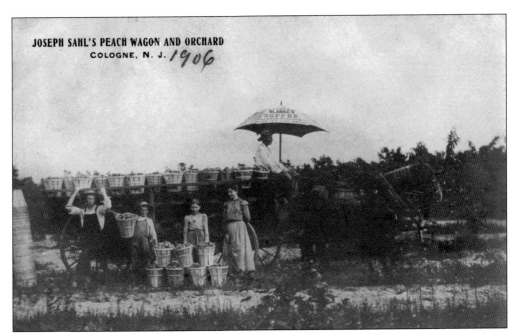

JOSEPH SAHL'S PEACH WAGON AND ORCHARD
COLOGNE, N. J. 1906

This postcard has a 1906 image of Joseph Sahl's peach orchard on it. The postcard, which was written in 1910 to Martha Sahl, expresses one person's regrets about not writing back right away and offers a promise to write back as soon as possible. The note is sincere and innocent and seems to emanate the emotions involved. (Courtesy of Willard and Loris Grunow.)

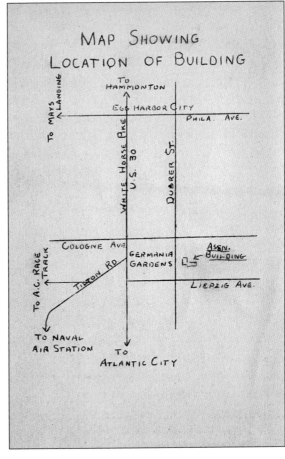

MAP SHOWING
LOCATION OF BUILDING

This map shows the location of the sweet potato storage and packing plant. The map was taken from the program of the official opening of the Atlantic County Market Growers Association, Cooperative, Inc. The event took place on Sunday, November 14, 1954. (Courtesy of Willard and Loris Grunow.)

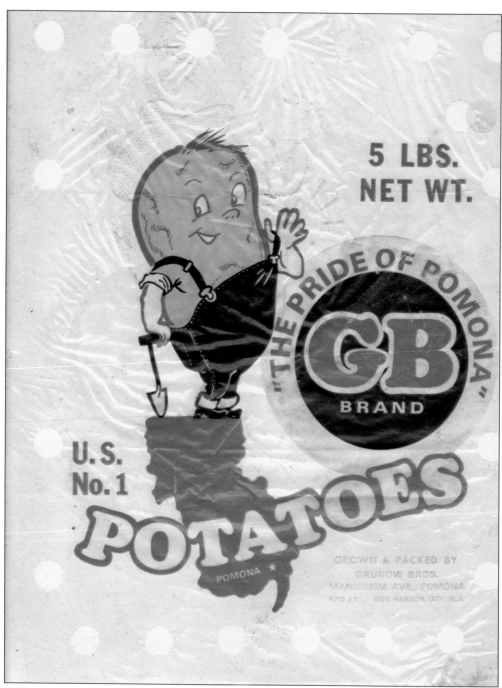

5 LBS.
NET WT.

"THE PRIDE OF POMONA"

GB
BRAND

U.S.
No. 1

POTATOES

POMONA

GROWN & PACKED BY
GRUNOW BROS.
MANNHEIM AVE., POMONA
RFD #1 EGG HARBOR CITY, N.J.

Willard Grunow and his ancestors had been farmers their entire lives. Willard still farms Christmas trees to this day, however, once upon a time, he grew potatoes. This 1950s logo is from an original packing bag from the Grunow farm. It is proof that farming is and will always be a true labor of love. (Courtesy of Willard and Loris Grunow.)

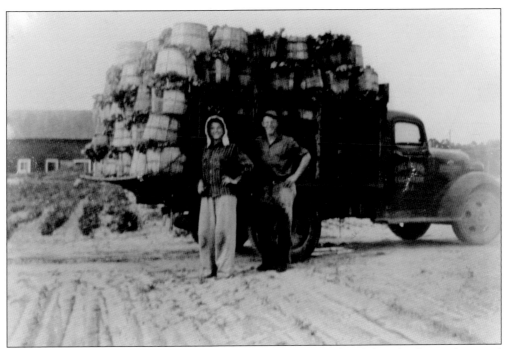

Ethel Roesch and her husband pose with their farm truck loaded with barrels of spinach around 1944. Ethel was born on January 8, 1905, and lived a long, happy life. She was known as "Aunt Ethel" to all and was a beloved member of the community. She passed away in July 2010. (Courtesy of the Galloway Township Historical Society.)

From left to right, Grandpop and Grandmom Killian pose outside of their farmland with young Leanard and Matt Bruckler and Uncle Len Bruckler. (Courtesy of the Galloway Township Historical Society.)

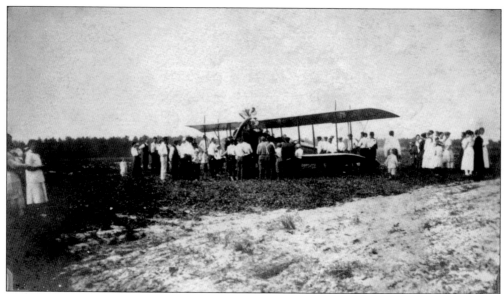

This *c.* 1920 image shows the first airplane to land in a farm field in Germania, Atlantic County. (Courtesy of the Galloway Township Historical Society.)

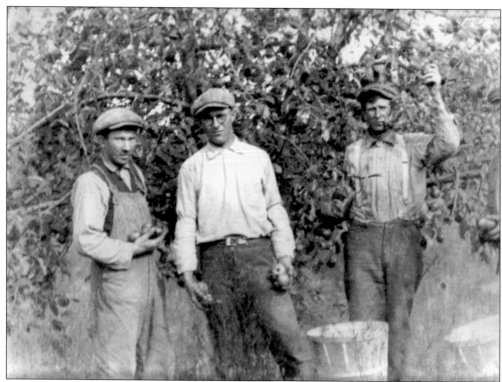

Charles Gaupp, William Hohneisen, Lawrence Kienzle, and Enail Buckow harvest apples in October 1918. (Courtesy of the Galloway Township Historical Society.)

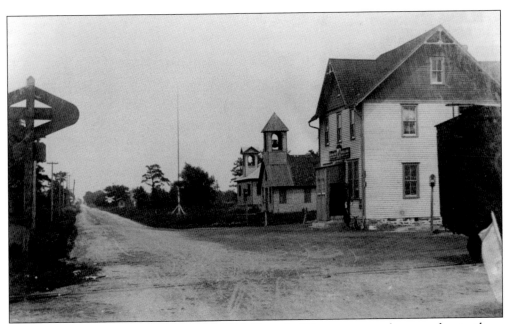

This is a picture of Cologne Avenue in 1915. Every building was very close together in those times. (Courtesy of the Galloway Township Historical Society.)

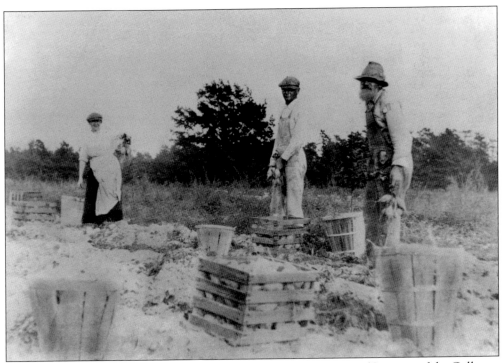

An unidentified family gathers for a day of harvesting sweet potatoes. (Courtesy of the Galloway Township Historical Society.)

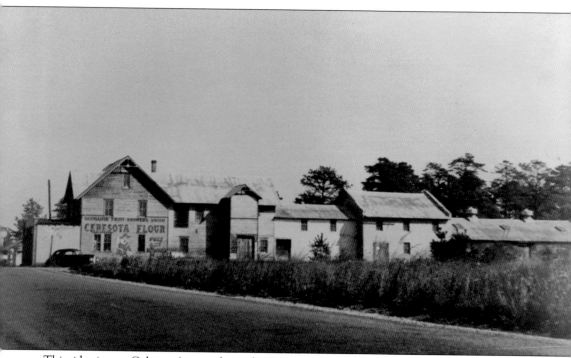

This side view on Cologne Avenue shows the Germania Fruit Growers Union and two schoolhouses. (Courtesy of the Galloway Township Historical Society.)

Three

SCHOOLS AND INDUSTRY

Almost all of the old schoolhouses where Galloway children once went to learn either do not exist anymore or have been converted to homes or businesses. Almost all of the school buildings in Galloway now are modern structures. Many of the historic buildings in the township have become inns or bed and breakfasts, like the Jonathon Pitney House on Shore Road. A unique aspect of where Galloway is situated on the bay is the development of small close-knit fishing villages and the restaurants that have been built up around them such as Motts Creek Inn and Oyster Creek Inn. When thinking about Galloway and industry, Lenox china comes to mind. Despite its retail outlet being closed in 2005, the company played an important role in the area, employing many local people and generating tourism. Risley Square, Leeds Point Shops, and The Shops at Smithville (not to be confused with Historic Smithville) have all been built within the past few decades to bring convenience and jobs to Galloway.

Speaking of tourism, the Seaview Resort, with its beautifully manicured lawns, gorgeous windows, and sweeping driveways off of New York Road, also known as Route 9, is outstanding. Currently owned and operated by Dolce Hotels and Resorts, the resort has seen many changes over the years and continues to prosper to this day. Seaview was originally built in 1912 by Clarence Geist, who wanted a private escape where he and his closest friends could play golf without the restriction of others' tee times and relax. After Geist's death in the late 1930s, it continued to operate as an exclusive country club. Notable guests included Pres. Warren Harding and Pres. Dwight Eisenhower, and Grace Kelly held her sweet 16 party at Seaview. From 1984, Marriott operated the hotel for many years, and in 2009, Dolce purchased the lodging. Seaview is a unique property, maintaining the gilded decadence of the past while serving customers with the latest in golfing and luxury. The resort also plays host to the annual LPGA ShopRite Classic, which returned to Seaview in 2010 after a three-year absence.

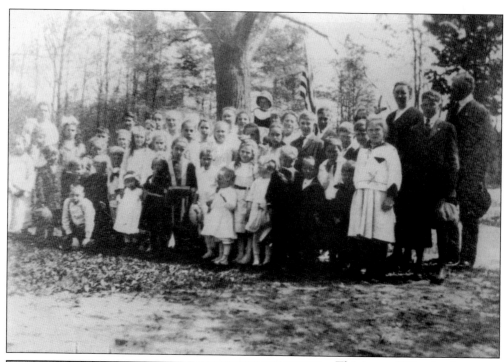

This is a c. 1921 school picture of the class at Germania School. (Courtesy of the Galloway Township Historical Society.)

Virginia M. Schaab Turner poses on her first day of school around 1906. (Courtesy of the Galloway Township Historical Society.)

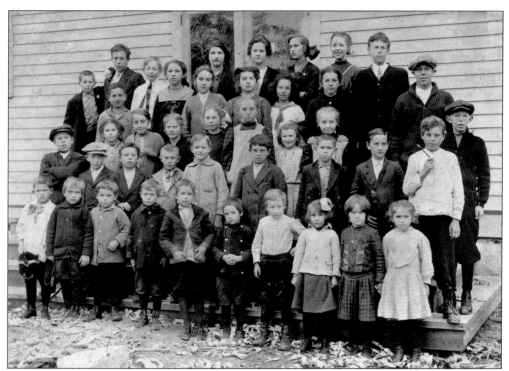

This is the class of 1915 at Germania School on Cologne Avenue. The students identified include Steve Eichinger, Geo Hoenes, Hen Sohn, Andy Stayman, Carol Hoenes, Bill Moeller, Fred Berggoetz, Walter Hoenes, Paul Hoenes, Paul Friedhofer, Mina Dreyer, and Theresa Eichinger, Lou Hanselmann, Marie Hoenes, Carthine Hill, Lillian Moeller, Elise Dreyer, Josephine Roesch, Christine Eichinger, Clara Roesch, and Gus Abulla, Walter Moeller, Ike Hoenes, Hen Henselmann, Walter Huenke, Anna Dreyer, Hilda Berggoetz, Martha Grube, Dot Browning, Lena Oeser, and Bill Hanselmann, Clara Dreyer, Marie Hanselmann, Bertha Moeller, Tilly Roesch, and Jack Hanselmann. Several children's names are not mentioned in this original photograph. (Courtesy of the Galloway Township Historical Society.)

Pictured here is a class at Smithville School. (Courtesy of the Galloway Township Historical Society.)

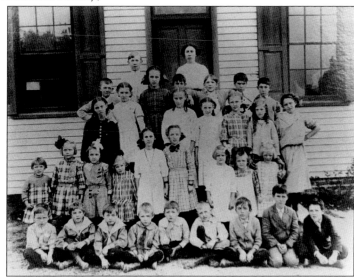

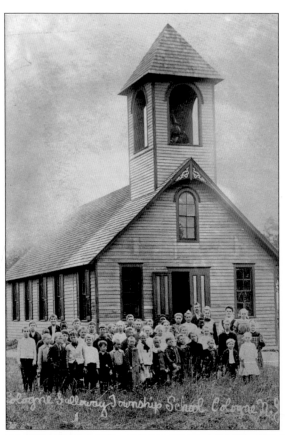

This class attended Cologne Township School on Cologne Avenue. It was located right next to the Fruit Growers Union. (Courtesy of the Galloway Township Historical Society.)

This is a class at Moss Mill Road School. Among these children are Dewald, Dreyer, Moeller, Roesch, Grube, and Hanselmann family members. (Courtesy of the Galloway Township Historical Society.)

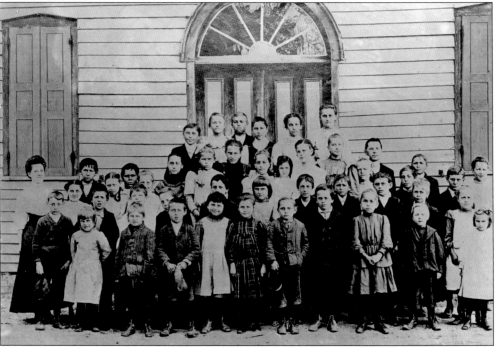

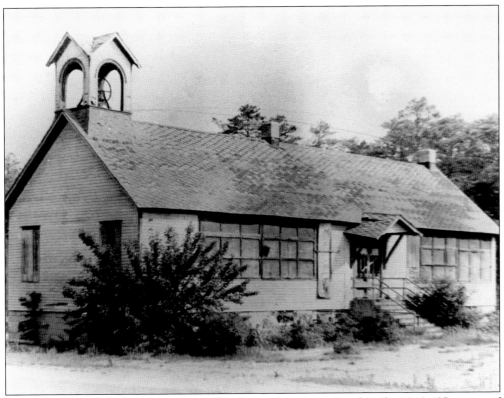

Here is a photograph of Conovertown School just after it was closed in the 1940s. (Courtesy of the Galloway Township Historical Society.)

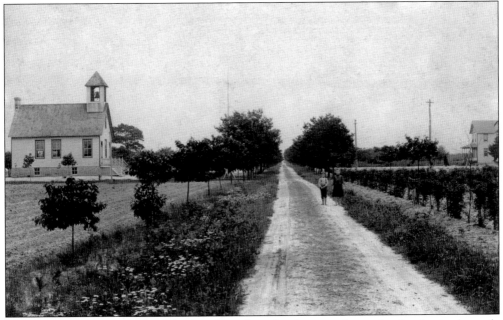

Two small, unidentified schoolchildren happily make their way home for the day in the early 1900s. (Courtesy of the Egg Harbor City Historical Society.)

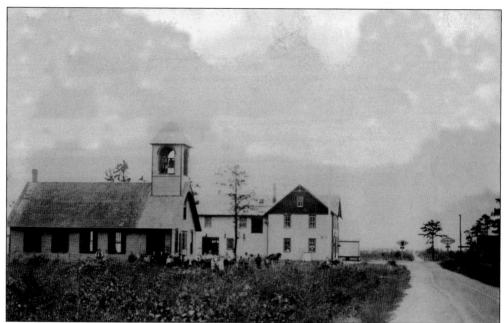

This is a *c.* 1900 photograph of the Cologne Schoolhouse. (Courtesy of the Egg Harbor City Historical Society.)

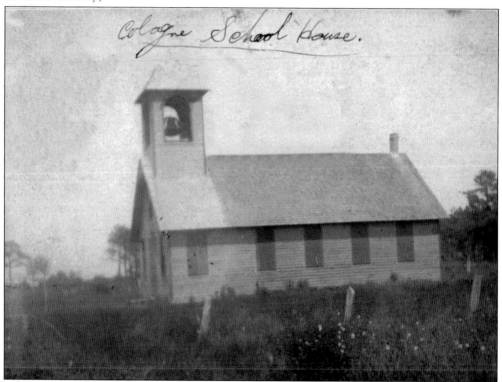

Cologne School House.

Here is the Cologne Schoolhouse located by the Fruit Growers Union market. The view is looking toward where White Horse Pike would be today. (Courtesy of the Egg Harbor City Historical Society.)

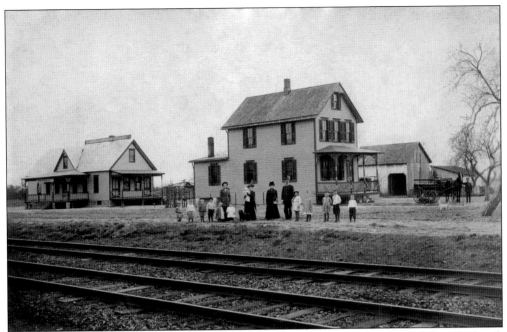

This is a picture of the American Salvation Army Orphanage, next to the Reading Railroad. Still proudly standing, this structure can be recognized to this day, except that it now has a small mall attached to it. (Courtesy of the Egg Harbor City Historical Society.)

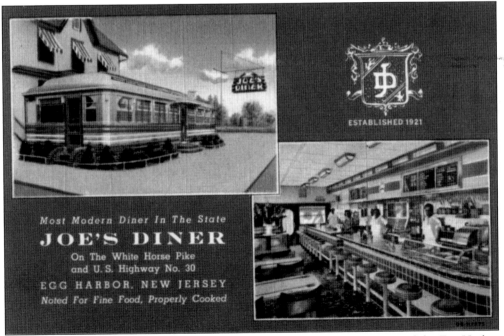

ESTABLISHED 1921

Most Modern Diner In The State

JOE'S DINER

On The White Horse Pike
and U.S. Highway No. 30

EGG HARBOR, NEW JERSEY

Noted For Fine Food, Properly Cooked

Here is an original place mat for Joe's Diner, established in 1921. (Courtesy of the Egg Harbor City Historical Society.)

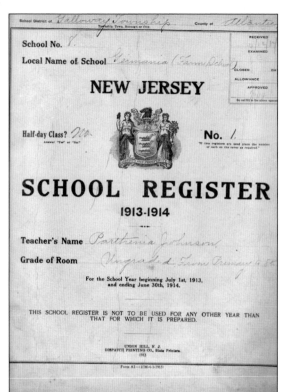

This original New Jersey School Register dates from 1914. It is the register for Germania School (Farm School), school No. 8. (Courtesy of Willard and Loris Grunow.)

Here is the 1951 teacher's contract for Loris Kienzle. In another teacher's contract from the 1980s, the salary jumped to over $25,000. (Courtesy of Willard and Loris Grunow.)

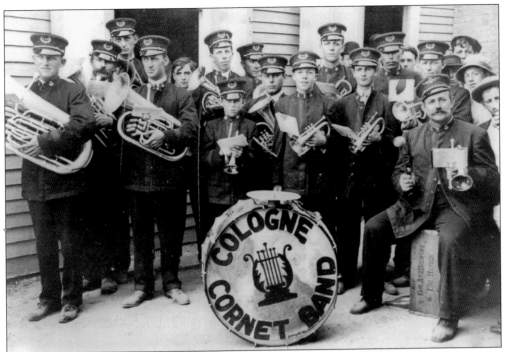

Around 1900, the Cologne Cornet Band poses before taking off on a parade route. (Courtesy of the Galloway Township Historical Society.)

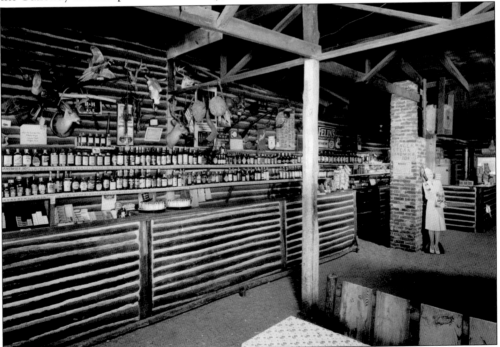

Pictured here is a liquor store and small deli in the 1930s or 1940s. Cigarettes, Felin's Frankfurters, and Spencer steak sandwiches were very cheap compared to today's prices. (Courtesy of the Galloway Township Historical Society.)

Seen here in the late 1800s, Kennedy's Bar is still located on White Horse Pike and Pomona Road. (Courtesy of the Galloway Township Historical Society.)

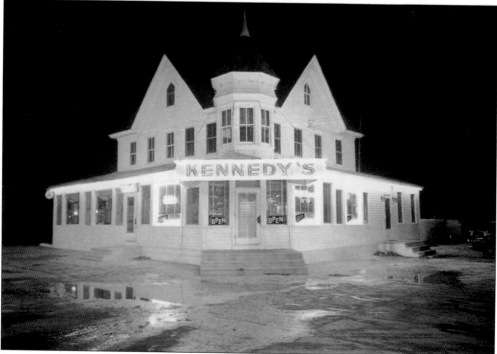

Here is an image of Kennedy's Bar in the 1950s. A favorite hangout and restaurant, it is still frequented today by many townspeople. (Courtesy of Kennedy's Bar and Grill.)

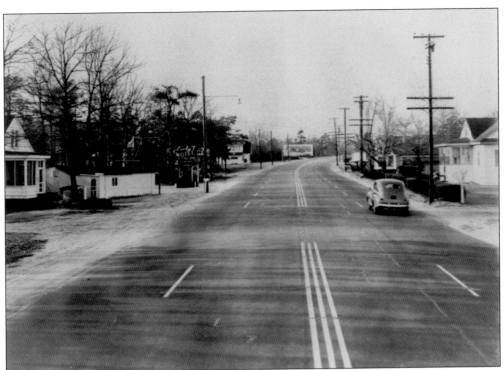

This is Route 30 (White Horse Pike) and Second Avenue before the Garden State Parkway overpass was built. (Courtesy of the Galloway Township Historical Society.)

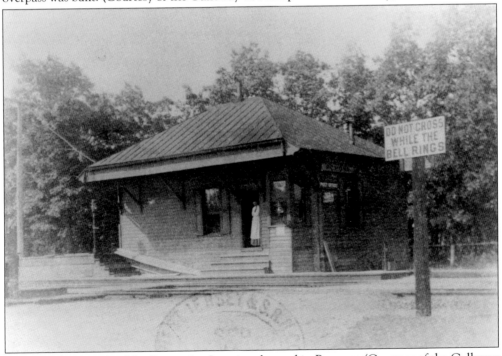

Here is a photograph of the Brigantine Junction, located in Pomona. (Courtesy of the Galloway Township Historical Society.)

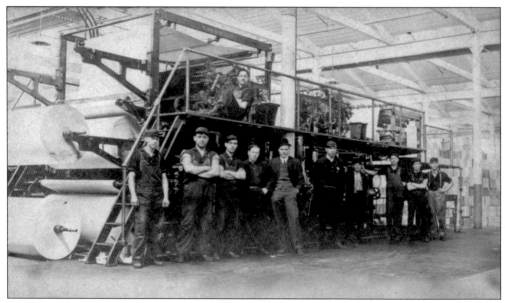

These hardworking men pose in the midst of a very long day at the plant. (Courtesy of the Galloway Township Historical Society.)

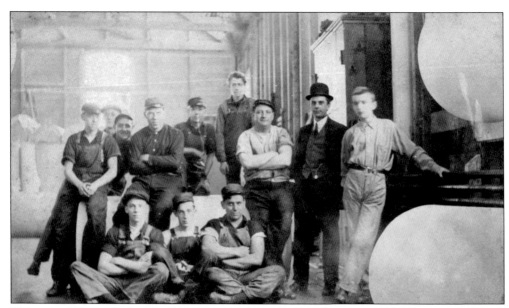

This group of men looks like they are not taking their work too seriously; they are, however, posing with their boss. (Courtesy of the Galloway Township Historical Society.)

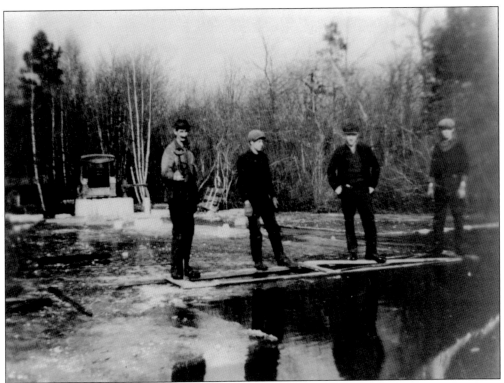

The Weber family is cutting ice, most likely at Clarks Landing. (Courtesy of the Galloway Township Historical Society.)

This 1930s image shows a structure built in the 1880s. (Courtesy of the Galloway Township Historical Society.)

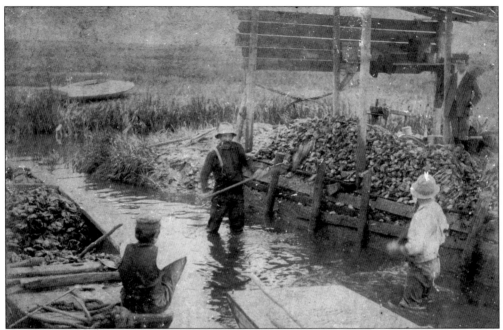

John Price Sr. is clamming in North Absecon. (Courtesy of the Galloway Township Historical Society.)

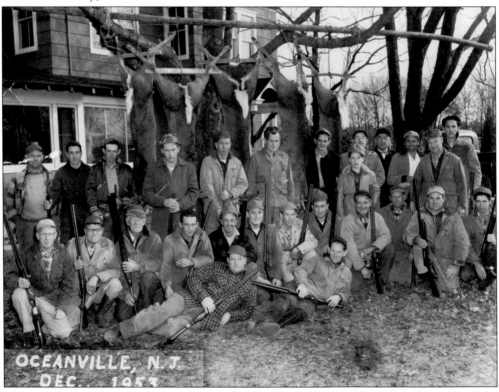

OCEANVILLE, N.J.
DEC. 1953

This is a picture of the gun club in Oceanville, New Jersey, in December 1953. (Courtesy of the Galloway Township Historical Society.)

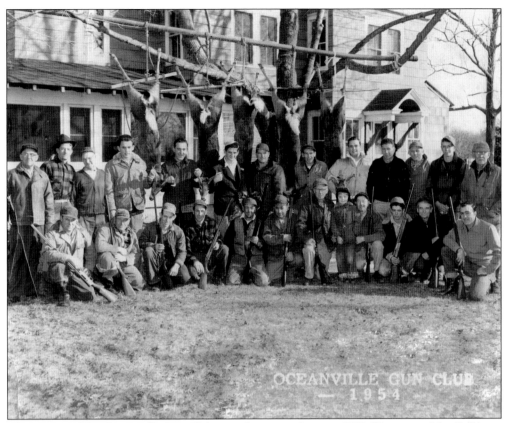

This picture of the Oceanville Gun Club was taken a year later, in 1954. (Courtesy of the Galloway Township Historical Society.)

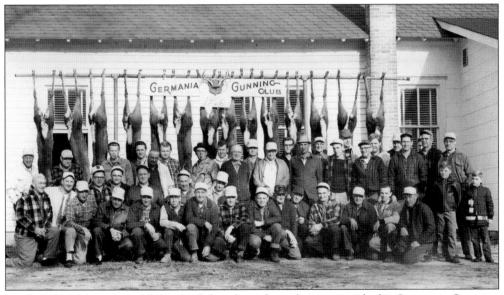

Uncle Bob Sahl, in front of the third deer from the right, poses with the Germania Gunning Club in 1966. (Courtesy of Jim and Anna Higbee.)

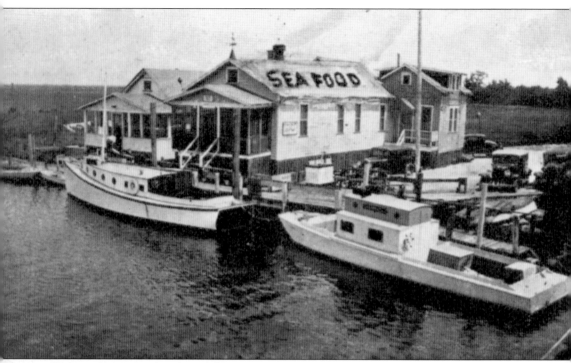

Here is an original postcard from Mischlich's seafood restaurant. (Courtesy of Jim and Anna Higbee.)

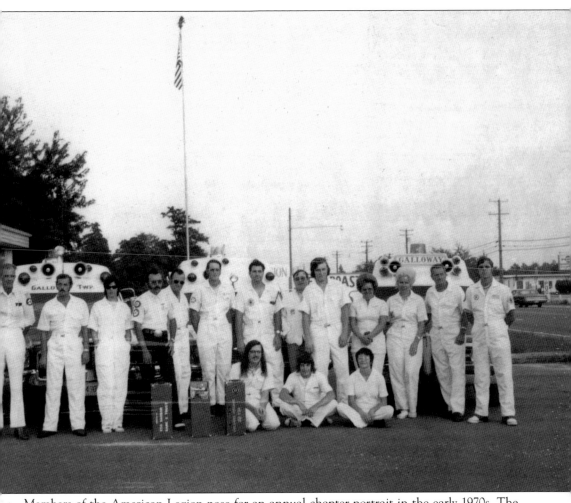

Members of the American Legion pose for an annual chapter portrait in the early 1970s. The American Legion was incorporated by Congress in 1919. (Courtesy of the Galloway Township Historical Society.)

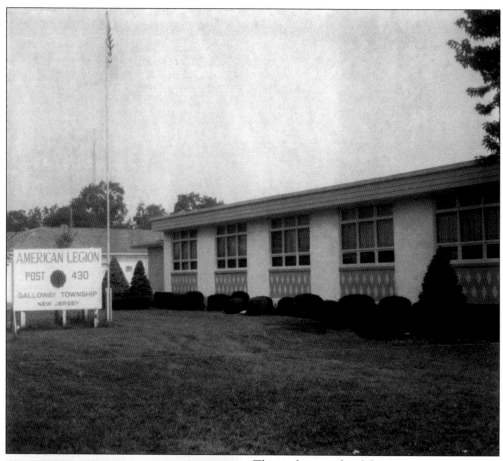

This is the outside of the American Legion building in the 1970s. (Courtesy of the Galloway Township Historical Society.)

Geo Friedhofer (left) and Arthur Rann pose at a town function. Arthur Rann lived from November 17, 1880 to January 19, 1969. He was quite a man and viewed both present and future needs with great understanding. He was also a well-respected contributor to the educational system in Galloway Township. (Courtesy of the Galloway Township Historical Society.)

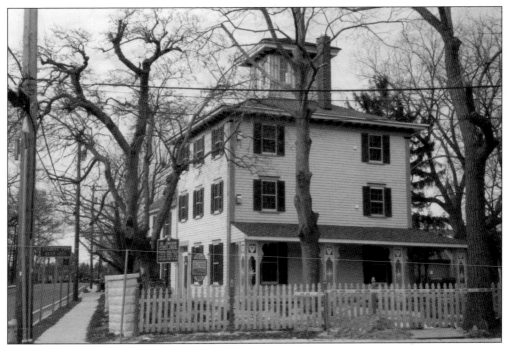

This is the Dr. Jonathan Pitney home as seen by Don Kelly, who purchased it in 1995. In 1798, Samuel Reed built the house. In 1820, Jonathan Pitney moved in as a boarder, as it had been a boardinghouse up until that point. Dr. Pitney got his license to practice medicine at the age of 22. (Courtesy of Don Kelly.)

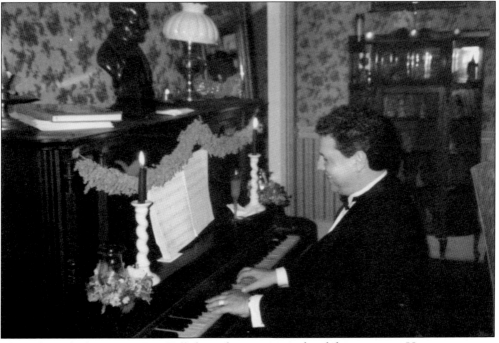

Throughout the late 1990s, Don Kelly hosted numerous weekend theme parties. Here a piano man can be seen happily entertaining guests in the formal living room. (Courtesy of Don Kelly.)

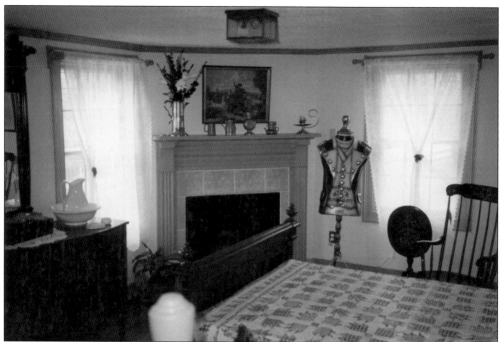

Don Kelly recreated guest quarters to bring a historical flare back to the house. This is a photograph of the physician's quarters. Inspired by the year 1848, the room includes a colonial desk and chair set, a Victorian dressing table, an armoire, and a 7-foot headboard above a comfortable bed. (Courtesy of Don Kelly.)

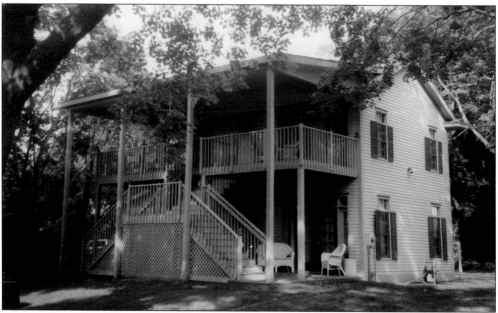

This is the rebuilt carriage house. Overall, the Dr. Jonathan Pitney house holds eight beds (six bedrooms), eight and a half baths, a pantry, a formal dining room that seats 10, and an office, which were all added in the late 1990s. Let it also be said that Dr. Jonathan Pitney encouraged investment in Atlantic City and has been called the father of that region. (Courtesy of Don Kelly.)

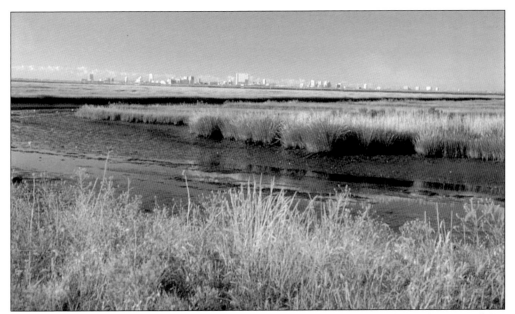

The Edwin B. Forsythe National Wildlife Refuge, located off of New York Road, is one of 500 nationwide run by the U.S. Fish and Wildlife Service (USFWS). This view from Wildlife Drive looking toward Atlantic City is just one of the beautiful views the refuge offers. (Courtesy of the USFWS.)

This stunning view of Doughty Creek in the wildlife refuge is just another example of the beauty that is to be found in Galloway Township. (Courtesy of the USFWS.)

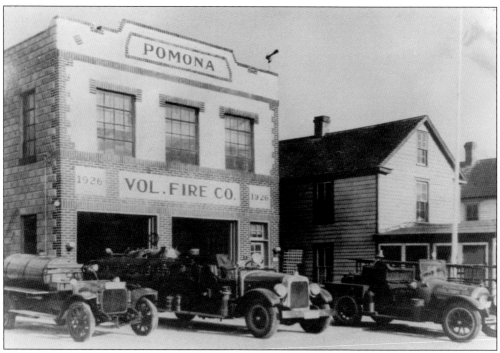

This is the Pomona Volunteer Fire Department, which was established in 1926. Up until 1924, Galloway Township used horses along with fire trucks. (Courtesy of the Galloway Township Historical Society.)

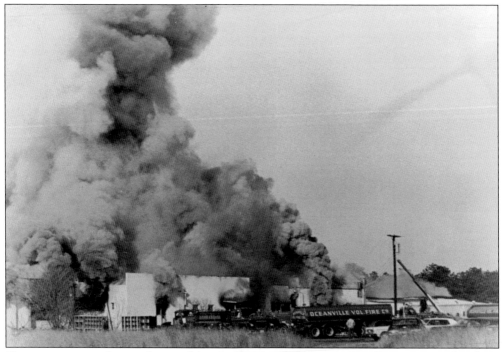

Here courageous volunteer firemen from the Oceanville Volunteer Fire Company put their lives on the line. (Courtesy of the Galloway Township Historical Society.)

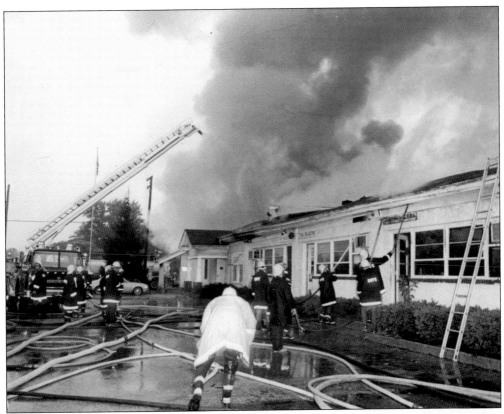

Volunteer firemen try their hardest to put out nasty and life-threatening flames. During this time, Calvin Brads served as mayor. (Courtesy of the Galloway Township Historical Society.)

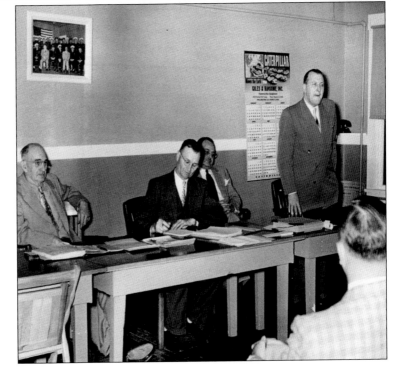

In 1954, prominent businessmen hold a meeting at the police department. (Courtesy of the Galloway Township Historical Society.)

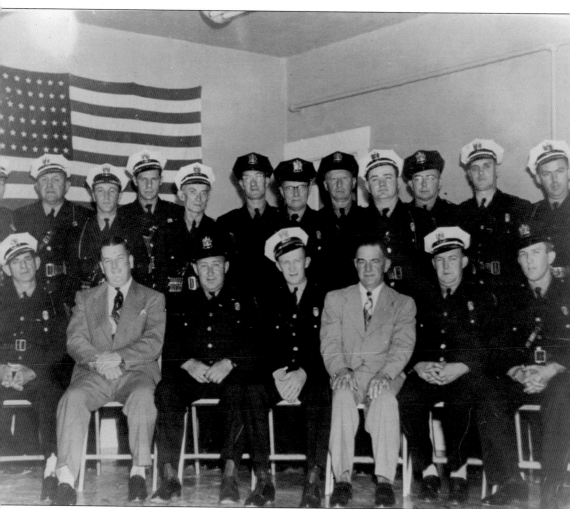

The *c.* 1954 police force poses for an annual portrait. In the previous image, this picture can be seen hanging in the top left corner. (Courtesy of the Galloway Township Historical Society.)

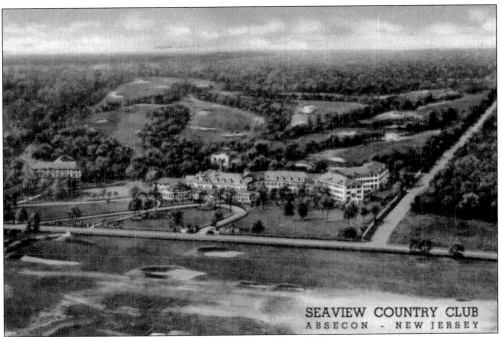

This is an overview of the Seaview Country Club. A country club from the 1930s, it was taken over by Marriott in the early 1980s. (Courtesy of the Galloway Township Historical Society.)

SEAVIEW COUNTRY CLUB
ABSECON, N. J.
★ A select Club featuring twenty-seven holes of "year 'round" golf in the pine and sea air. Luxurious accommodations. Famed service and cuisine. Indoor salt water pool, fishing, hunting, riding. Nine miles from Atlantic City.

This is the back of the above postcard. It was from Bert, who was down at the Seaview Country Club for a good rest. Clearly Seaview was the place to be. (Courtesy of the Galloway Township Historical Society.)

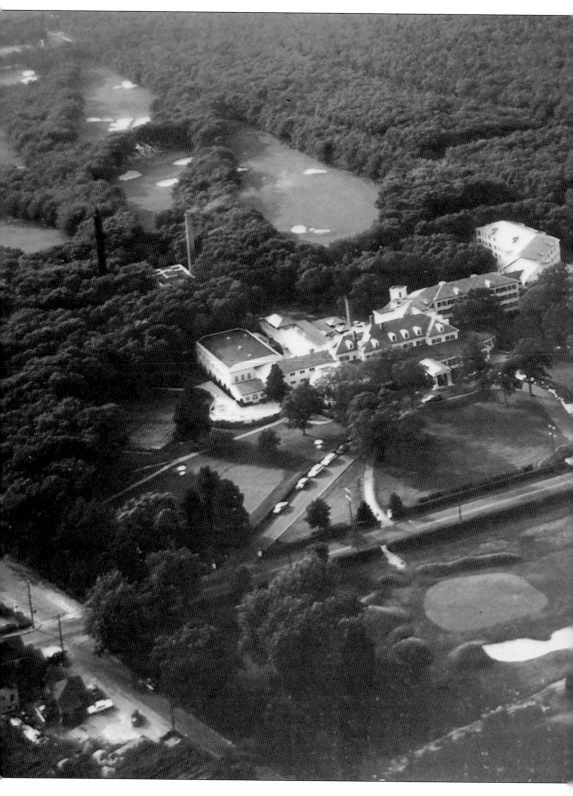

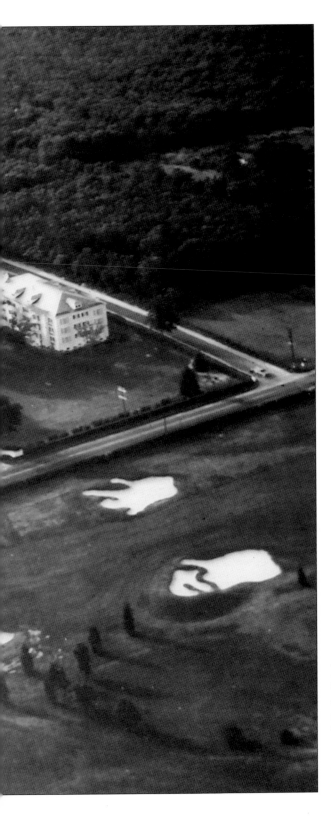

Here is an aerial photograph of the Seaview Resort, possibly while still owned by Marriott. It is currently a Dolce Resort. A little-known fact is that in the winter of 1989, the Rolling Stones, Jerry Hall, and Eric Clapton dropped by the hotel along their travels. (Courtesy of Seaview, a Dolce Resort.)

This is a photograph of the Seaview Golf Club garage. Robert Sahl can be seen standing second from right in the white shirt and black tie. (Courtesy of Jim and Anna Higbee.)

An unidentified member of the Sahl family poses with an airplane on the Seaview golf grounds on September 25, 1923. (Courtesy of Jim and Anna Higbee.)

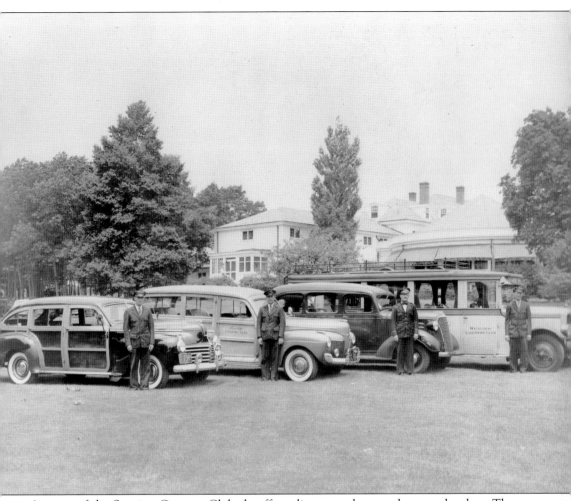

A group of the Seaview Country Club chauffeurs line up to have a photograph taken. These chauffeurs include, from left to right, Henry Smith, Harry May, Ferdinand, and Robert Sahl. (Courtesy of Jim and Anna Higbee.)

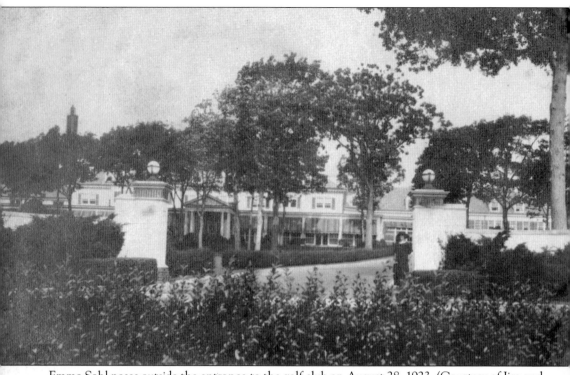

Emma Sahl poses outside the entrance to the golf club on August 28, 1923. (Courtesy of Jim and Anna Higbee.)

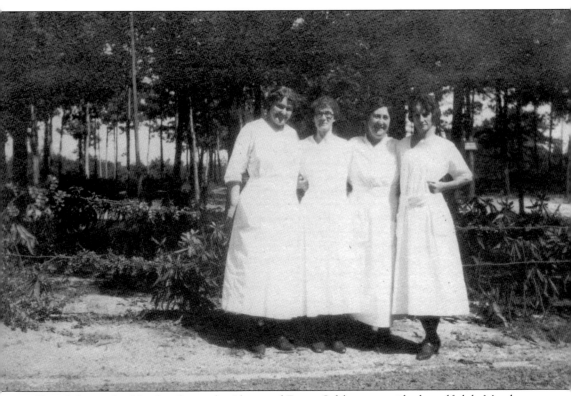

From left to right, Martha, Gertrude, Alice, and Emma Sahl pose outside the golf club. Members of the Sahl family were trustworthy employees at the club for many years. (Courtesy of Jim and Anna Higbee.)

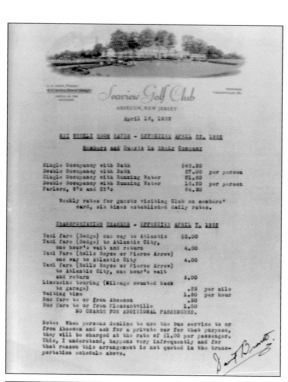

This is a list of the 1932 Seaview Golf Club room rates along with information about transportation going to and from the resort to various places around the area. The name of the manager and original builder, Clarence M. Geist, appears in the upper left-hand corner. (Courtesy of Seaview, a Dolce Resort.)

This announcement from 1933 is a real sign of the times. An unmarried man and woman traveling together must sleep in different rooms on different floors of the hotel, "in order to avoid any embarrassing situations." (Courtesy of Seaview, a Dolce Resort.)

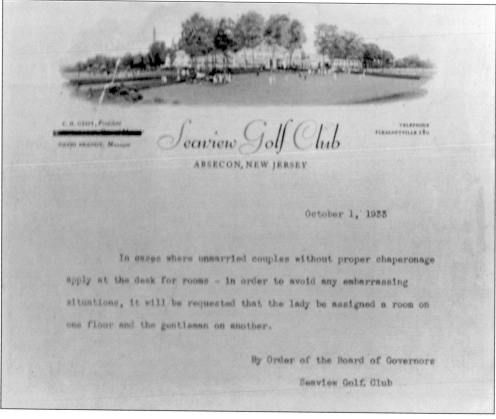

Four

RENAULT WINERY

At one time, Galloway Township and the surrounding areas were known for their vineyards. In fact, the building the historical society uses for its various meetings and events was once the tasting room of one of these local wineries. Perhaps the most famous of these is the Renault Winery. Louis Nicholas Renault lived in the Champagne region of France before moving to the United States in 1863. The next year, he opened Renault Winery. Louis Nicholas Renault passed away in 1913 at the age of 92.

From 1913 to the beginning of Prohibition, Renault's son Felix took control of the business. During this time, the winery made a fortune selling Renault Wine Tonic (only sold during this time), which had supposed medicinal purposes and a warning label: "Caution: do not refrigerate this product as it may turn into wine." Renault was one of the few wineries in the entire country that not only survived Prohibition but actually turned a profit during that era. John Andrea D'Agostino, who died in a tragic automobile accident in 1948, was the second owner of Renault until his mother took over the business in 1941. Her daughter Marie owned the company from 1972 until 1977, when Joseph Milza took it over. Milza is still the owner today.

The winery has become an important tourist attraction with a hotel, fine dining restaurant, and golf course. A fun piece of trivia is that Renault champagne was featured prominently in the 1941 film *Gambling Daughters*.

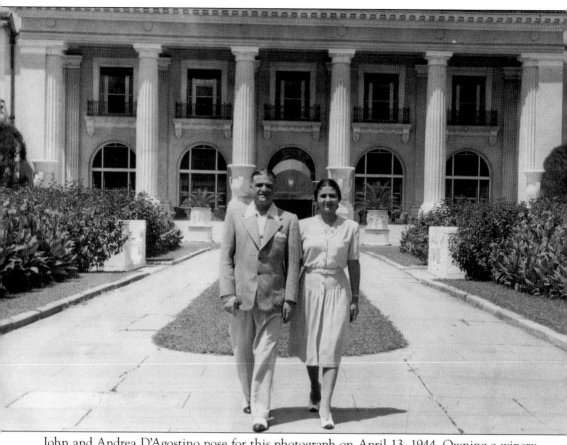

John and Andrea D'Agostino pose for this photograph on April 13, 1944. Owning a winery certainly has its perks, as they were on vacation in Palm Beach, Florida, in this photograph. (Courtesy of Jim and Anna Higbee.)

John and Andrea D'Agostino graciously accept an award at The Breakers Hotel in Palm Beach, Florida, on April 3, 1945. (Courtesy of Jim and Anna Higbee.)

The stately John and Andrea D'Agostino are captured mid-stride before heading out for a night on the town. (Courtesy of Jim and Anna Higbee.)

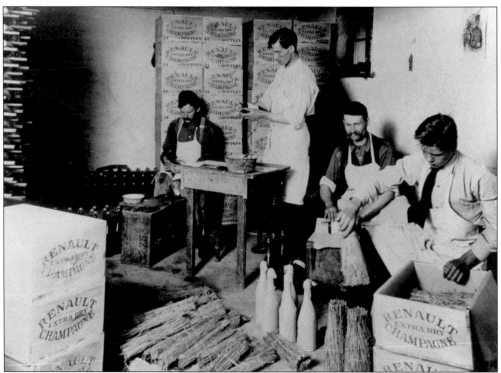

These hardworking men are packing extra dry Renault champagne. (Courtesy of Jim and Anna Higbee.)

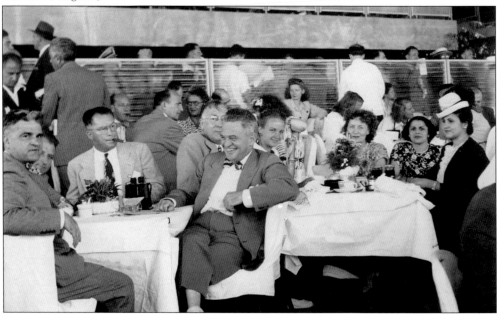

This is Renault tycoon Johnny D'Agostino (far left) and a party of unidentified cronies. The vivacious redhead directly behind the D'Agostino party (fourth from right at the front table) is singing star Terry Lawlor, who eventually appeared at the Bath and Turf Club. (Courtesy of Sherzer's Photo Shop.)

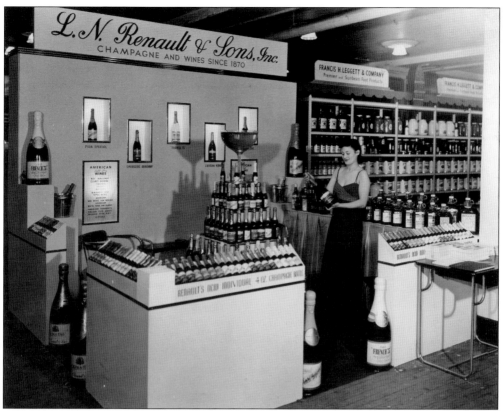

This is an L. N. Renault and Sons, Inc., store display from the 1940s. (Courtesy of the Renault Winery.)

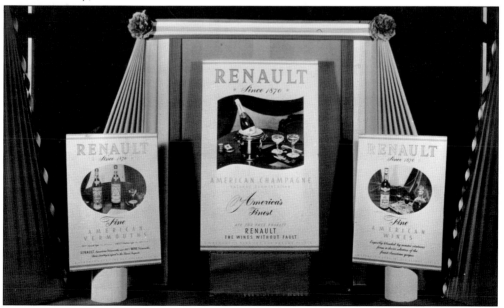

Here are bottles of Renault champagne beautifully displayed around 1941. (Courtesy of the Renault Winery.)

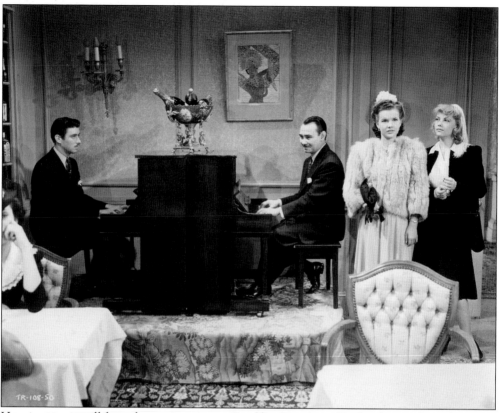

Here is a movie still from the motion picture *Gambling Daughters*. To this day, product placement is the key to a business's success. (Courtesy of the Renault Winery.)

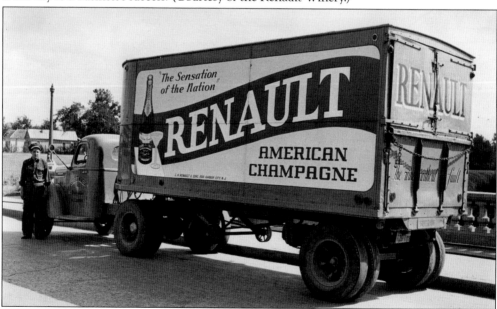

This is an official Renault truck in the 1940s or 1950s. The slogan on the back of the truck states, "The wine without fault." (Courtesy of the Renault Winery.)

This is the storefront to Eddie's Wine and Liquor in the late 1940s. (Courtesy of the Renault Winery.)

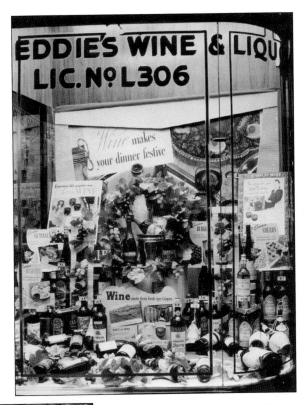

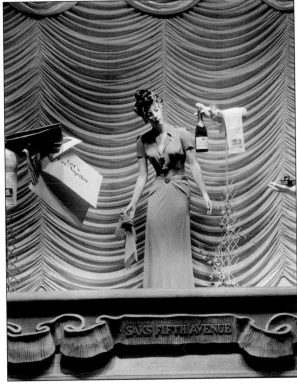

Renault spirits were so popular they even made it into a window display at Saks Fifth Avenue in New York City in the 1940s. (Courtesy of the Renault Winery.)

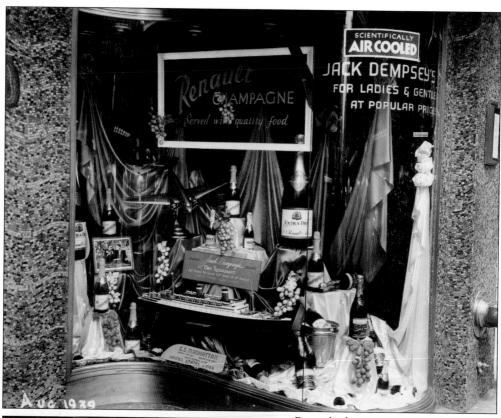

Renault champagne is seen here at Jack Dempsey's storefront in August 1939. (Courtesy of the Renault Winery.)

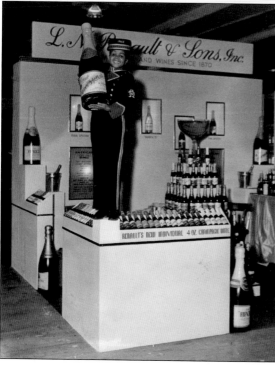

This woman proudly displays the brand-new Renault bottles. (Courtesy of Edward Ozern.)

This showcase is an example of how wineries in the Prohibition era sold their products without getting caught. Renault Wine Tonic was supposedly great for health and only held 22 percent alcohol in the 1930s. (Courtesy of the Renault Winery.)

Renault was very clever in covering up the fact that it was still selling its products. Here a smiling nurse sits, attempting to entice a buyer or two. (Courtesy of the Renault Winery.)

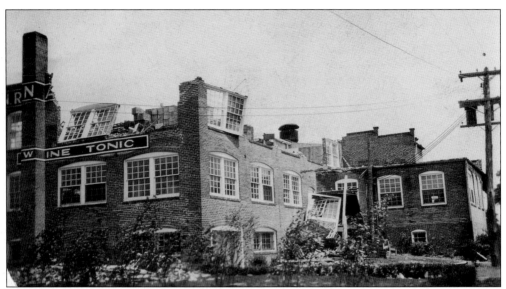

This is the original building where the Wine Tonic was made. This photograph was taken on June 9, 1928. (Courtesy of the Renault Winery.)

This is a publicity still from the motion picture *In Dreams Only*. (Courtesy of the Renault Winery.)

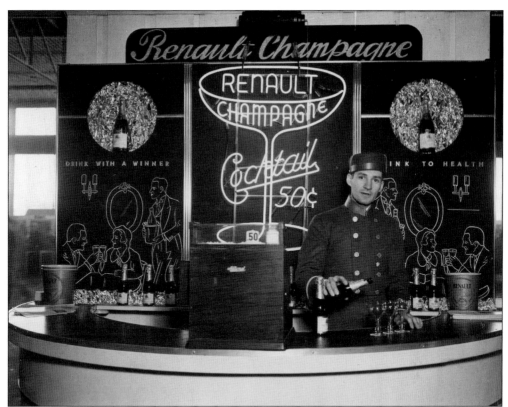

A 1950s bellhop smoothly pours out some Renault champagne in order to make a 50¢ cocktail for all to enjoy. (Courtesy of the Renault Winery.)

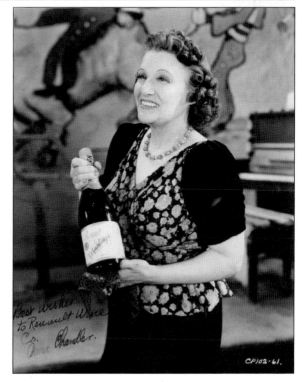

Actress Anna Chandler proudly poses with a Renault product. She was born February 27, 1887, and died July 10, 1957. This still dates most likely from around 1941. (Courtesy of the Renault Winery.)

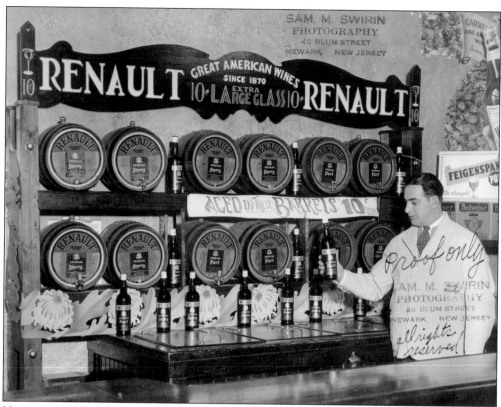

Here is a *c.* 1930 still shot promoting an extra large glass filled with a public favorite for only 10¢. (Courtesy of the Renault Winery.)

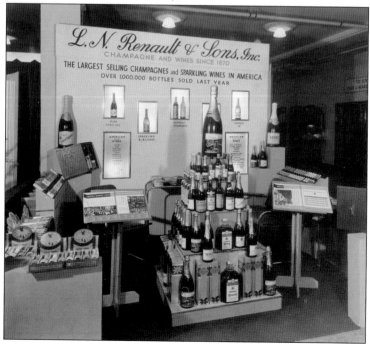

This beautiful display of Renault wine bottles in 1939 includes all kinds of shapes and sizes. Renault's most prominent wine is blueberry champagne. (Courtesy of the Renault Winery.)

Five

SMITHVILLE

In 1787, James Baremore built the Smithville Inn as a stagecoach stop on the line that ran from Leeds Point to Cooper's Ferry in Camden, New Jersey. As stagecoach travel declined, the original inn was disassembled and rebuilt on Brigantine Island. Then, in the 1960s, Fred and Ethel Noyes began the process of restoring the inn, turning it into a restaurant. Later, the business expanded into an entire village of historical buildings bought and rebuilt from various locations throughout New Jersey. It was later sold to the National Broadcasting Company (NBC) in 1974 for $7 million. It should be noted that the village had its busiest day on Mother's Day 1973, serving over 6,000 meals. The working colonial village had 25 structures, which included a drugstore, a schoolhouse, a boathouse, and a church. In the 1980s and early 1990s, the village was taken over by a group of lawyers, but they were unsuccessful at running the enterprise. The site lay vacant for five years until Ed and Wendie Fitzgerald took control of the Village Green, opening a bed and breakfast and various shops in the building on that side. Across the bridge, the Coppolas own and operate what is now the Smithville Inn along with more shops and a restaurant named Fred and Ethel's, after the vivacious couple who brought a little history back to Galloway.

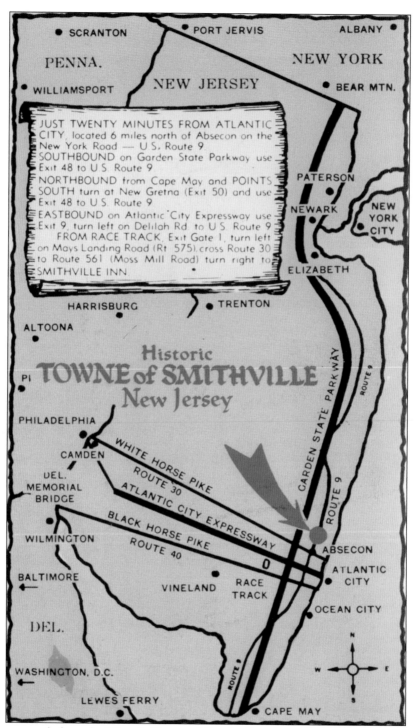

This is a map of where the Historic Towne of Smithville is located today. Ethel Noyes played a big part in creating the beautiful grounds that eventually became the village everyone can enjoy today. She and her husband expanded the little historic area between the years 1948 and 1975. (Courtesy of Jim and Barbara Ingersoll.)

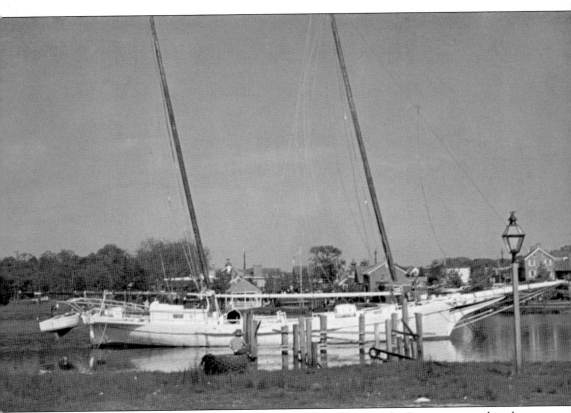

This is a picture of the famous boat in Smithville called the *Bugeye*. The *Bugeye* appeared in the rough waters of the bay in the late 1860s. For years it served as the centerpiece to a simpler place and time but eventually got taken away from Smithville. (Courtesy of Jim and Barbara Ingersoll.)

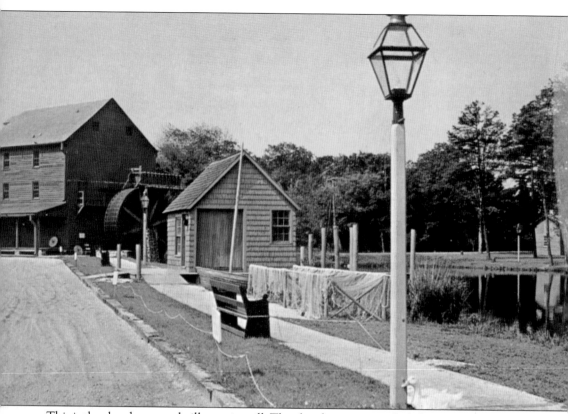

This is the clam house and village gristmill. The clam house originally belonged to Baker Bowen, who for many years engaged in the clam and oyster business in nearby Oyster Creek. The village gristmill is over 170 years old. This image does not show the bridge or boardwalk that now occupy the area. (Courtesy of Jim and Barbara Ingersoll.)

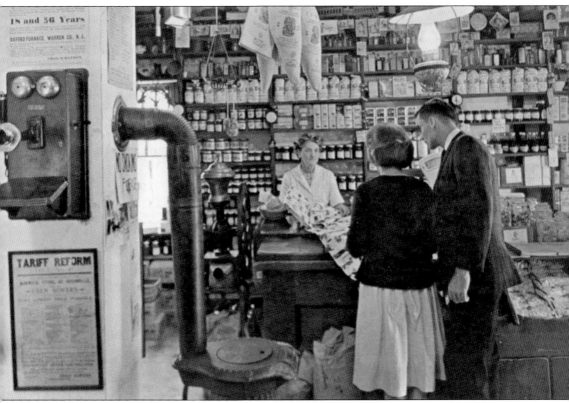

This is the country general store. The old country general store is over 110 years old and was one of the first country stores in southern New Jersey. It has been fully restored to its original charm and usefulness. The manner in which the people are dressed in this image evokes a simpler place and time. (Courtesy of Jim and Barbara Ingersoll.)

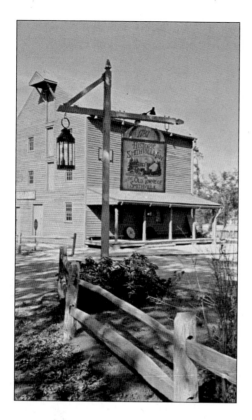

This is a modern angle of what the gristmill looks like. (Courtesy of the Galloway Township Historical Society.)

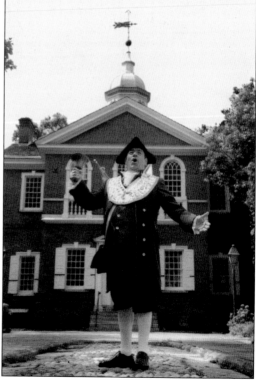

Richard LaLena visits Smithville about 12 times a year and on all major holidays. Here he can be seen sporting his James Baremore costume that also doubles as the costume for the town crier. Today's criers lead parades and open special events. LaLena is the founder of the American Guild of Town Criers. (Courtesy of Richard LaLena.)

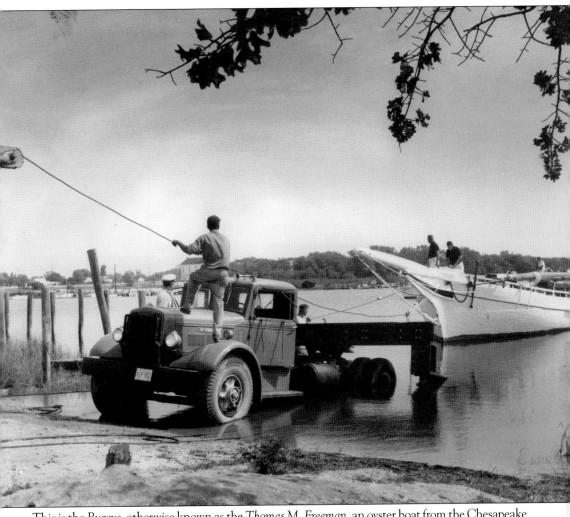

This is the *Bugeye*, otherwise known as the *Thomas M. Freeman*, an oyster boat from the Chesapeake Bay. This particular ship eventually ended up in Port Republic. The photograph is of the ship being hauled by a small group of men from the Nacote in Port Republic. It was then moved to Smithville and set to rest in Lake Meone in the mid- to late 1960s. (Courtesy of Judith Courter.)

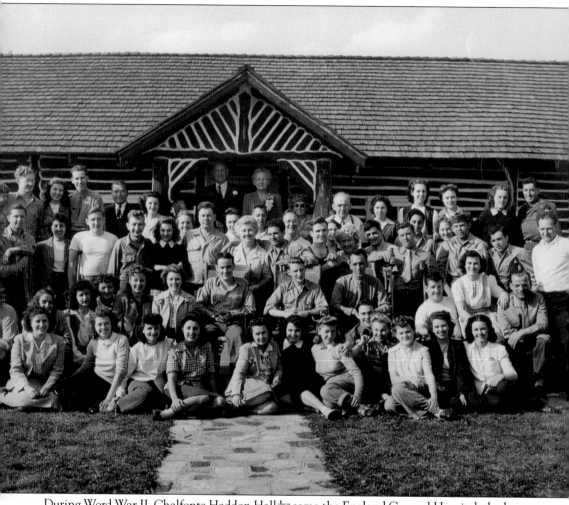

During Word War II, Chalfonte Haddon Hall became the England General Hospital, the largest amputee hospital in the world. Ethel Lingelbach's parents, Chris and Caroline Lingelbach, as well as another family pitched in and rented a cabin on Lily Lake. Under the leadership of Mamie Stone, Egg Harbor postmistress and a Gray Lady, local young men and women in Galloway Township brought the wounded amputees from England General Hospital on weekends to "The Cabin" for cookouts as well as tons of entertainment. In this *c.* 1945 photograph, Fred and Ethel Noyes are directly in front of the couple in the center of the back row, Ethel's parents. (Courtesy of Judith Courter.)

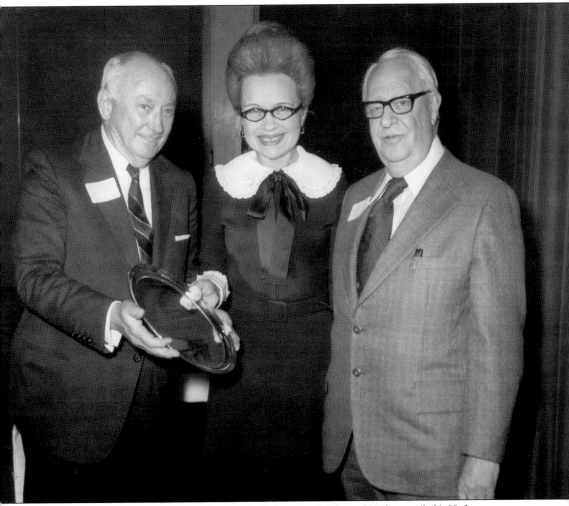

This is a c. 1968 photograph of Fred and Ethel Noyes with Elwood Kirkman (left). Kirkman was a prominent attorney, president of the Boardwalk Bank, and real estate magnate. The award is believed to be from the Atlantic County Hotel Motel Association. (Courtesy of Judith Courter.)

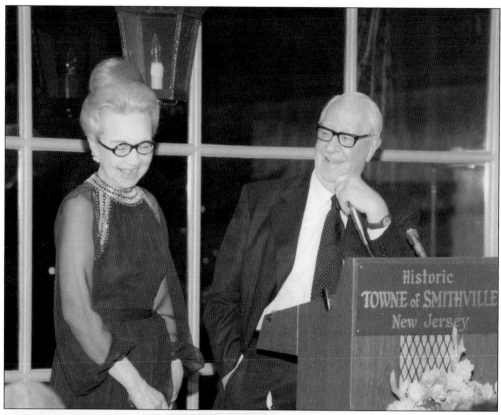

Fred and Ethel Noyes are laughing at the podium and clearly enjoying each other's company. The Noyeses received the Mainlander of the Year Award on November 16, 1974. (Courtesy of Judith Courter.)

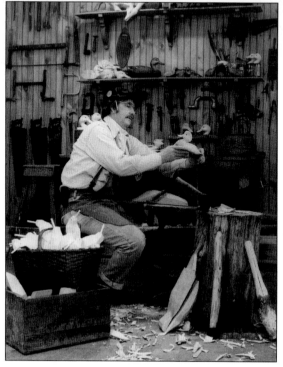

Gary Giberson is carving away at the Noyes Museum when it opened in 1983. He is a wonderful storyteller and craftsman. Giberson has been mayor of Port Republic since 1990. (Courtesy of Judith Courter.)

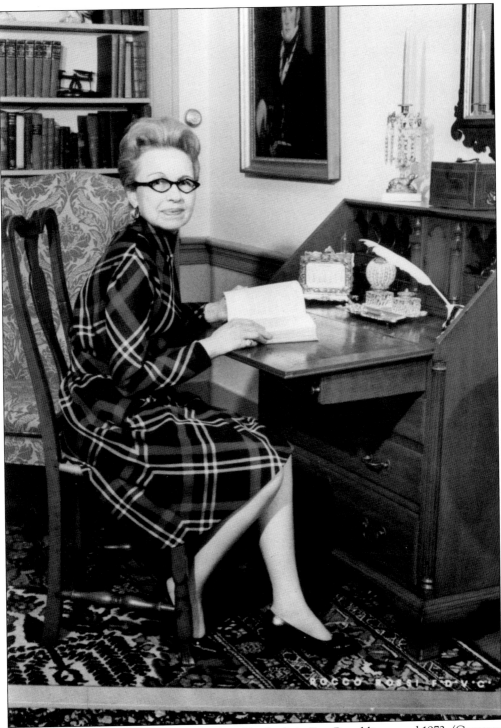

Ethel Noyes is handsomely posing in her humble abode in Port Republic around 1972. (Courtesy of Judith Courter.)

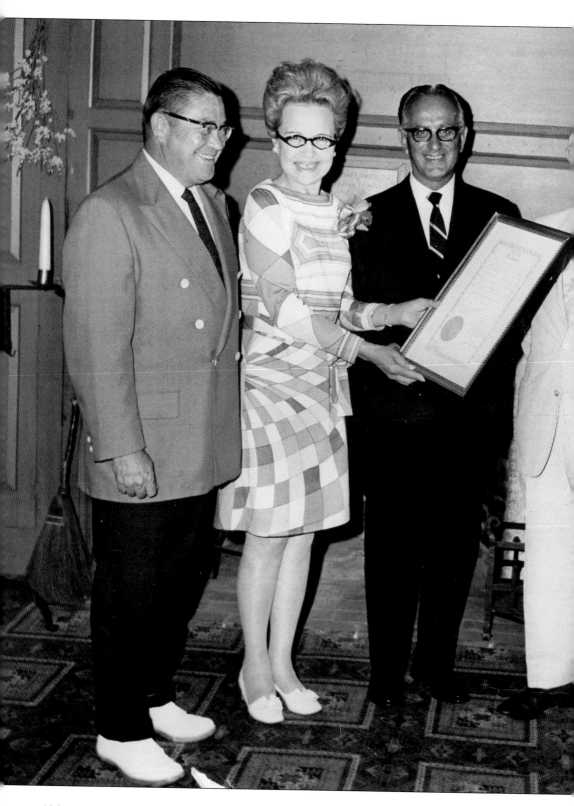

Here the prominent Noyes family presents an award in 1970. (Courtesy of Ed and Wendie Fitzgerald.)

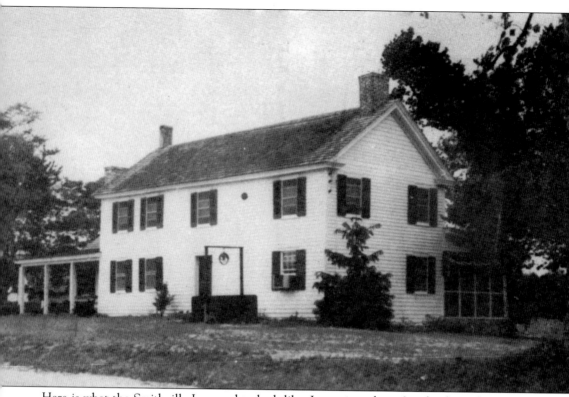

Here is what the Smithville Inn used to look like. It was just about 3 miles from the Seaview Country Club. (Courtesy of Ed and Wendie Fitzgerald.)

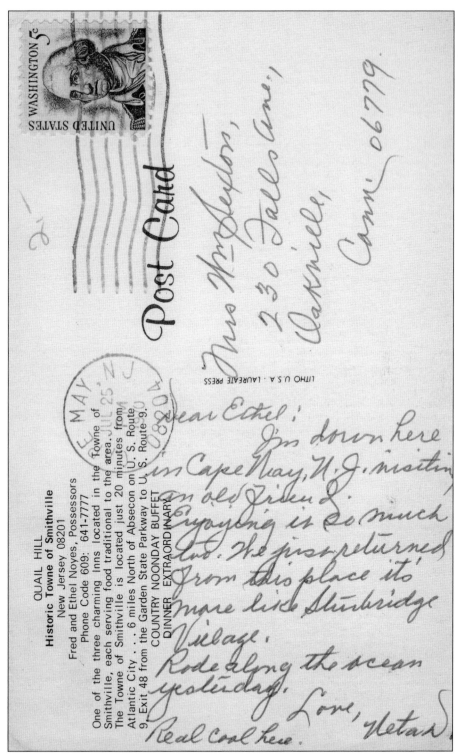

Here is a postcard to Ethel Noyes. Ethel was a force to be reckoned with and loved by all. (Courtesy of Ed and Wendie Fitzgerald.)

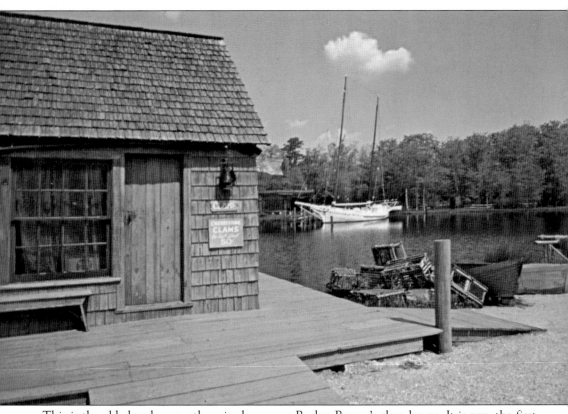

This is the old clam house, otherwise known as Becker Bowen's clam house. It is now the first shop after the bridge in Smithville. Ethel Noyes brought it over to her historic town. (Courtesy of Ed and Wendie Fitzgerald.)

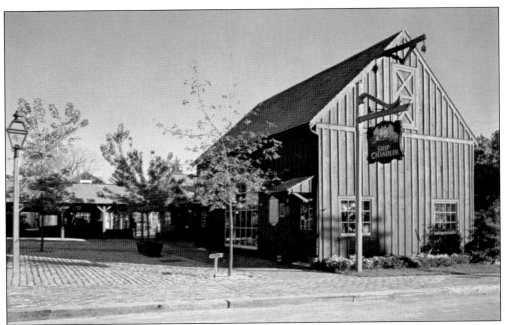

This is a postcard of the Ship Chandler. The words on the back say, "Brim full of all sorts of things pertaining to the sea. Wares to please the 'landlubber' as well as the sailor!" (Courtesy of Ed and Wendie Fitzgerald.)

This tiny shack is the bootmaker's shop. (Courtesy of Ed and Wendie Fitzgerald.)

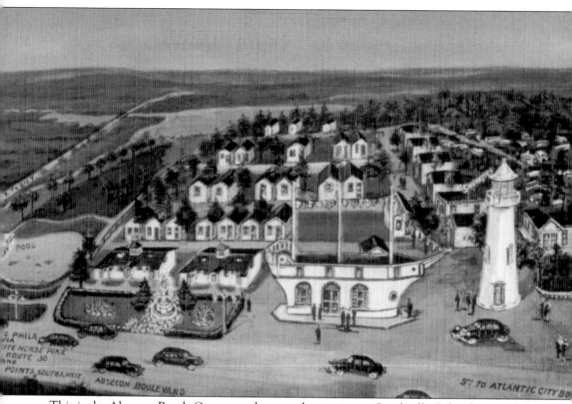

This is the Absecon Beach Camp, an alternate destination to Smithville. It has been said that it was once under contract to become a housing development, but plans eventually fell through. This fortress of times past can still be seen heading to Atlantic City and other shore points. (Courtesy of Ed and Wendie Fitzgerald.)

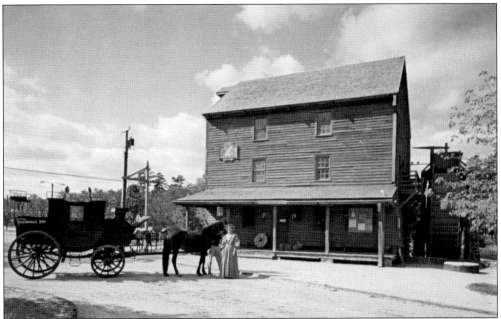

Here is yet another important image of the gristmill. The mill was moved from Sharptown, New Jersey, to its current location. (Courtesy of Ed and Wendie Fitzgerald.)

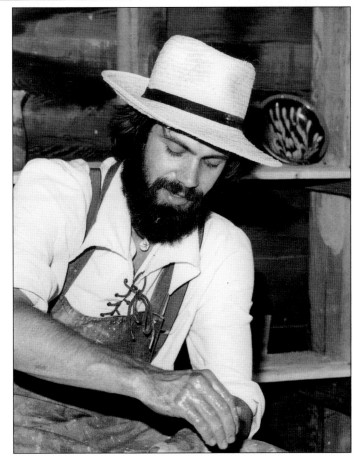

This is Don van Brunt, who worked in Smithville as the potter in the old village. Ethel Noyes required her staff to dress in period clothing to give off a more realistic effect. (Courtesy of Ed and Wendie Fitzgerald.)

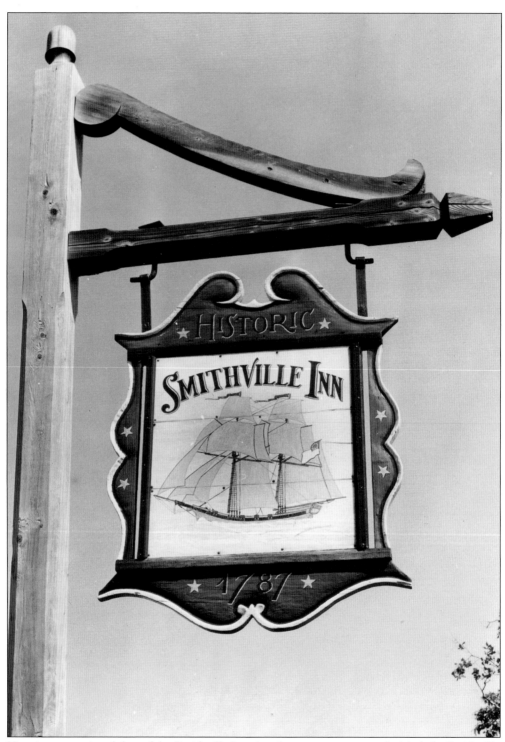

Here is a promotional shot of the Smithville Inn sign that guests are greeted with daily. Smithville holds over 400 events a year. (Courtesy of Ed and Wendie Fitzgerald.)

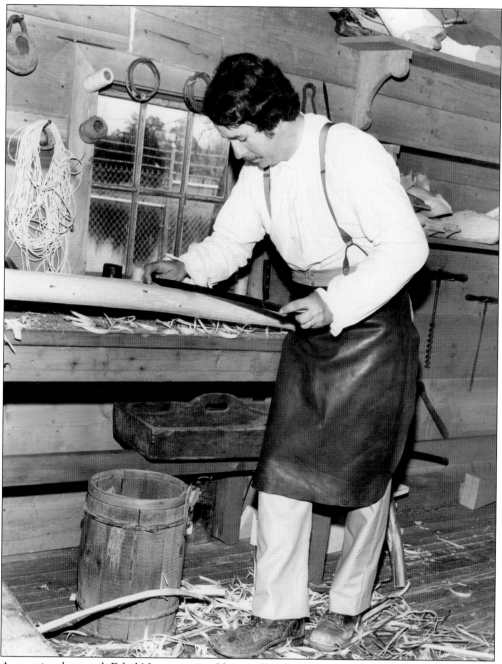

As previously stated, Ethel Noyes required her staff to dress up in period costumes while on the Smithville premises. This man can be seen hard at work giving a public wood carving demonstration. (Courtesy of Ed and Wendie Fitzgerald.)

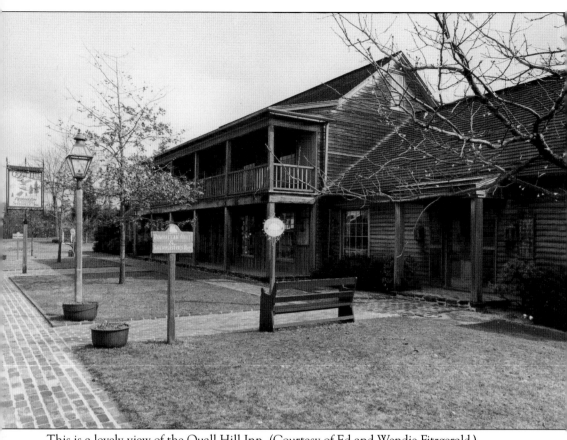

This is a lovely view of the Quall Hill Inn. (Courtesy of Ed and Wendie Fitzgerald.)

Six

WARS

Chestnut Neck played an important role in the American Revolution. Protected by sandbars and small channels off the coast, it became prime real estate for privateers, who legally raided enemy ships in the name of the Continental Congress. One such raid occurred on a British ship carrying a vast amount of goods that so angered a British general in New York that he sent ships down to take care of the "Nest of Rebel Pirates," as he so named them. A storm delayed the invasion and gave the colonists time to seek help from General Livingston, although they were sidetracked to Tuckerton instead. The battle-ready British overtook the rebels and destroyed a dozen or so buildings in the area along with saltworks and previously captured British ships. Despite this, no Americans were actually killed or captured, and it was not considered a great win on the British side. In October 1911, the Lafayette division of the Daughters of the American Revolution erected a monument near the Chestnut Neck Boat Yard to commemorate the battle.

Galloway also played an important role during World War II with the Black Point Air Station, where bomb tests were practiced. Several planes working out of Black Point crashed in the area surrounding the range, one crashing in the Smithville area and one in the Absecon Highlands.

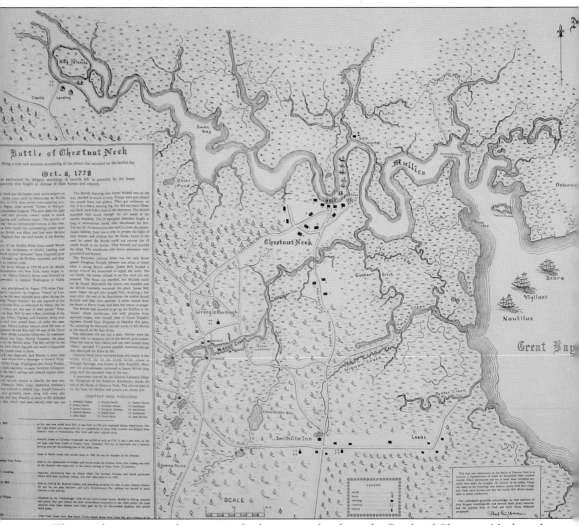

This is a historic map that intricately shows exactly where the Battle of Chestnut Neck took place. There is a monument dedicated to the battle, which was erected in 1911. It is right in the center of the image where it says "Chestnut Neck." Many organizations such as the Daughters and the Sons of the American Revolution are now preparing for the monument's 100th anniversary. (Courtesy of the Galloway Township Historical Society.)

Here is an image of Robert Sahl from World War I. He lived in Port Republic and worked at Seaview. Sahl comfortably passed away in his home. (Courtesy of Jim and Anna Higbee.)

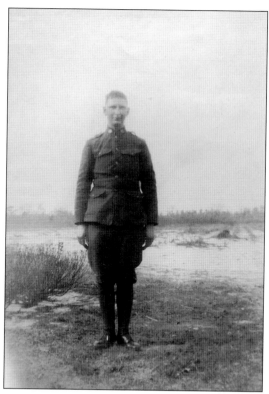

An unidentified American soldier happily poses as he returns home from World War I. (Courtesy of the Galloway Township Historical Society.)

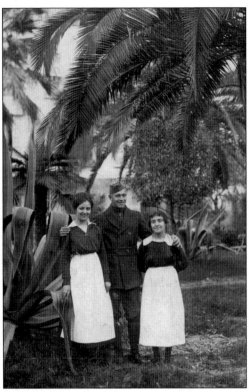

An unidentified World War I soldier poses with unidentified women. (Courtesy of the Galloway Township Historical Society.)

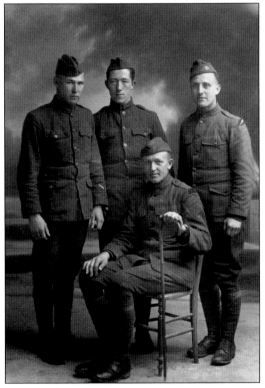

A group of men about to go off to battle pose for the camera. The unidentified man standing in the middle can also be seen in the chapter on family, posing for a portrait. (Courtesy of the Galloway Township Historical Society.)

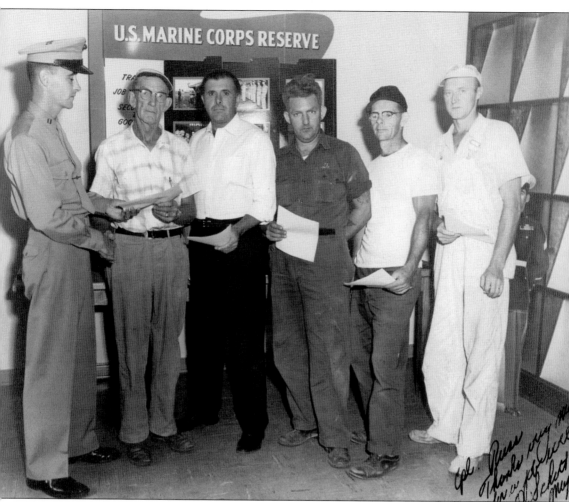

A group of men line up to receive their papers. (Courtesy of the Galloway Township Historical Society.)

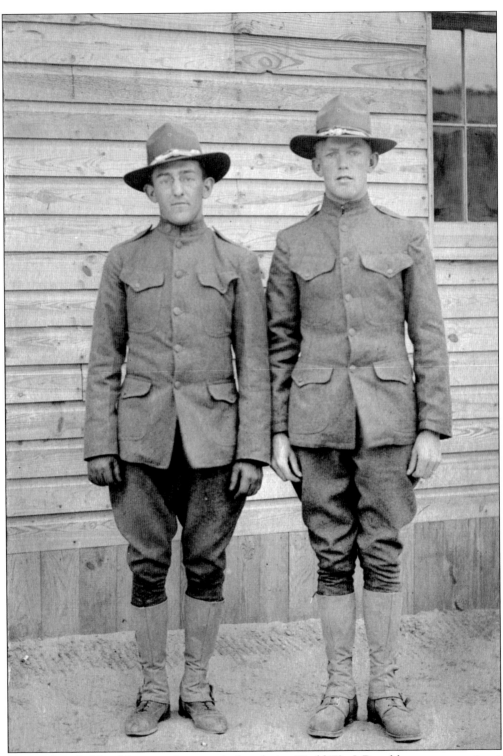

Two unidentified doughboys stand at a semi salute during World War I. Doughboys were prominent between 1914 and 1918. (Courtesy of the Galloway Township Historical Society.)

Seven

FOLKLORE

Many readers will have heard of the Jersey Devil. Chances are that they did not know the legend of the Jersey Devil was born right in Galloway Township. The story goes that in 1735, Mother Leeds supposedly exclaimed right before giving birth to her 13th child, "Let this one be a devil!" And she got her wish. When the baby was born, it had the head of a horse, hooves like a donkey, and wings like a bat. It flew out the chimney into the storming night and has been haunting the area ever since.

The sad reality is that more than likely, a child was born to someone in the area, Leeds or not, that was deformed or possibly mentally challenged. Times being what they were, the child was hidden away from the rest of the society and shrouded in mystery. This, coupled with fears of witchcraft as far back as the Quakers, made fodder for local legends and stories to pass down generation to generation. The Jersey Devil seems friendly, if not a nuisance; it has been blamed for cattle deaths and bad luck but never once for the injury or death of a human being.

The Jersey Devil is not the area's only legend. It is said the famous privateer Captain Kidd, when faced with the betrayal and threat of arrest from the Crown, supposedly hid a bit of treasure in the area where Galloway now sits. Whether this is true or not may never be known since Kidd was eventually arrested and later sent to London to pay for crimes he was falsely accused of. He was never actually able to properly defend himself.

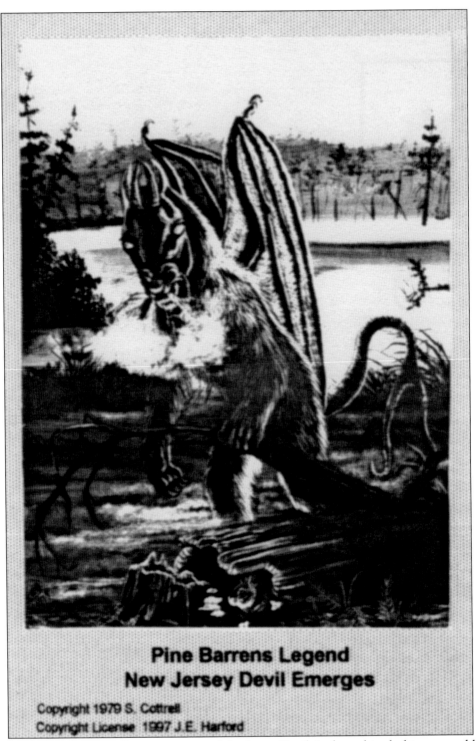

**Pine Barrens Legend
New Jersey Devil Emerges**

Here is a more "realistic" representation of the Jersey Devil. It shows him lurking around his premises; it is frightening to imagine coming in close proximity to such a creature. It is also known as the "Leeds Devil" to this day. (Courtesy of Ed and Wendie Fitzgerald.)

© 1969 Ed Sheetz

THE JERSEY DEVIL

THE LEGEND OF THE JERSEY DEVIL
(Famous New Jersey Folklore Character)

Since the early 1700's, there have been many accounts of the "Jersey" or "Leeds Devil". Descriptions vary from "horsefaced" to "collie faced"- from a large furry creature of a reddish brown "colour", with bat - like wings, cloven hoofs, horns and a forked tail, to an impish, nattily dressed character who delights in scaring people half out of their wits. In days gone by, he has been sighted in the Pine Barrens, Port Republic, New Gretna and many other "nearby" towns. Some say his birthplace was in the Leeds Point area, near Smithville, and that he roamed the swamps along the Mullica River. Most agree that a woman named Leeds (thought to be a witch) having twelve children already, and finding herself with child again, cursed it and wished that the offspring be born a devil. She got her wish apparently, and from that day on the Legend of "The Jersey Devil" became a part of New Jersey folklore.

This image is a little more playful. The Jersey Devil is everywhere nowadays. His image can be seen on T-shirts, books, pens, album covers, and most popularly, postcards. (Courtesy of Ed and Wendie Fitzgerald.)

THE JERSEY DEVIL
mixing his favorite brew

The Jersey Devil has been used countless times for the sake of publicity. In this image, he can be seen mixing up his favorite brew. Who knew the Jersey Devil liked to take a break from his haunting from time to time? (Courtesy of Ed and Wendie Fitzgerald.)

BIBLIOGRAPHY

McGloy, James F. and Ray Miller Jr. *The Jersey Devil.* Moorestown, New Jersey: Middle Atlantic Press, 1999.

McMahon, William. *Historic Towne of Smithville.* Egg Harbor City, New Jersey: Laureate Press, 1967.

Niceler, Dennis M. *Gemuetlichkeit, Stories from the days of the Glouster Farm and Town Association.* 2010.

www.arcadiapublishing.com

Discover books about the town where you grew up, the cities where your friends and families live, the town where your parents met, or even that retirement spot you've been dreaming about. Our Web site provides history lovers with exclusive deals, advanced notification about new titles, e-mail alerts of author events, and much more.

Find Your Place in History.